MW00635304

Merry Christmas!
From, Kathy, Brent & Jenn
2018

NOVA SCOTIA
AT NIGHT

Len Wagg

NIMBUS
PUBLISHING

Best wish
L Wagg

Copyright © 2017, Len Wagg

All rights reserved. No part of this book may be reproduced, stored in a retrieval system or transmitted in any form or by any means without the prior written permission from the publisher, or, in the case of photocopying or other reprographic copying, permission from Access Copyright, 1 Yonge Street, Suite 1900, Toronto, Ontario M5E 1E5.

Nimbus Publishing Limited
3731 Mackintosh St, Halifax, NS B3K 5A5
(902) 455-4286 nimbus.ca

Printed and bound in Canada

NB1318

Design: Jenn Embree

Library and Archives Canada Cataloguing in Publication

Wagg, Len, photographer
Nova Scotia at night / Len Wagg.
ISBN 978-1-77108-522-9 (hardcover)
1. Night photography—Nova Scotia. 2. Nova Scotia—Pictorial works. I. Title.

FC2312.W326 2017 971.60022'2 C2017-904065-0

Nimbus Publishing acknowledges the financial support for its publishing activities from the Government of Canada, the Canada Council for the Arts, and from the Province of Nova Scotia. We are pleased to work in partnership with the Province of Nova Scotia to develop and promote our creative industries for the benefit of all Nova Scotians.

THIS BOOK IS DEDICATED TO ALEXA THOMPSON AND

SUSAN HAWKINS, TWO INSPIRING WOMEN WHO WERE

TAKEN FROM US TOO SOON. THEIR STARS SHINE BRIGHT

IN THE NIGHT SKY.

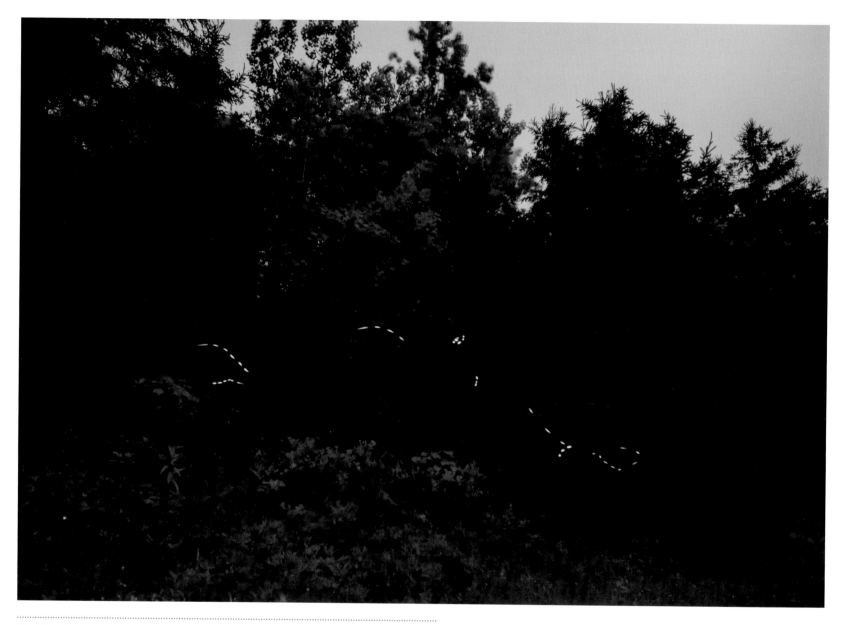

Fireflies leave a pattern in the sky as they try to attract members of the opposite sex. They produce light though a process called bioluminescence. One of the advantages of today's cameras is the ability to shoot in low light without too much loss of image quality. This picture was taken at 10:30 on a dark night, but appears much brighter.

FEATURED PHOTOGRAPHERS

ONE OF THE FANTASTIC USES OF SOCIAL MEDIA IS THE ABILITY TO SHARE IMAGES AND FIND like-minded people who share your passion. We are blessed to have some fantastic photographers in Nova Scotia, both professional and amateur. The ability to shoot, post, and get feedback while you're still at a shoot has brought our craft to a whole new level. I wanted to devote a few pages of this book to featuring some of my favourite photographers. The common theme for all of them is that their work shows passion, curiosity, and creativity. I hope you enjoy their work as much as I do.

Pam Collins

It seems that Pam Collins from Wild Sweetpea Photography never sleeps. Images on her feed go from the early-morning twilight of a breaking dawn through the setting sun and dark Milky Way. She shoots lots on the Eastern and North Shore and brings a section of the province to life. Her images also have a great environmental feel, which helps illustrate our sense of place.

Instagram: wildsweetpeaphotography
Email: tapmap@gmail.com

T. J. Maguire

T. J.'s images have graced the social media wavelengths for many years, but I think it was his jaw-dropping image of the Halifax Central Library that really caught everyone's attention. I think without a doubt he created an image that stands above the rest of one of the most photographed buildings in Halifax. His composition, lighting, and technical detail are fantastic. For more of TJ's work visit: tjm.ca

Adam Hill

Most of you have probably seen Adam Hill's work and if not do a quick search on the Internet and find out what you are missing. Adam has worked for the most part in the Northwest Territories and has brought that section of the country to life with his mesmerizing night images. Originally from Cape Breton, he is moving back and we can look forward to his talents here. His image of the lightning bug helped me push my traditional limits a few years ago and his work is inspiring! For more of Adam's work visit: adamhillstudios.ca

Tim L'Esperance

A man of many talents, Tim spends most of his time flying helicopters and has honed his skills as an aerial photographer. He also has a knack for being in the right place at the right time and is probably one of the few people who can say they were on the top of the Angus L. Macdonald Bridge DURING the fireworks show. Working with the technical crew, he was able to create some second to none images! For more of Tim's work visit: timlesperance.com

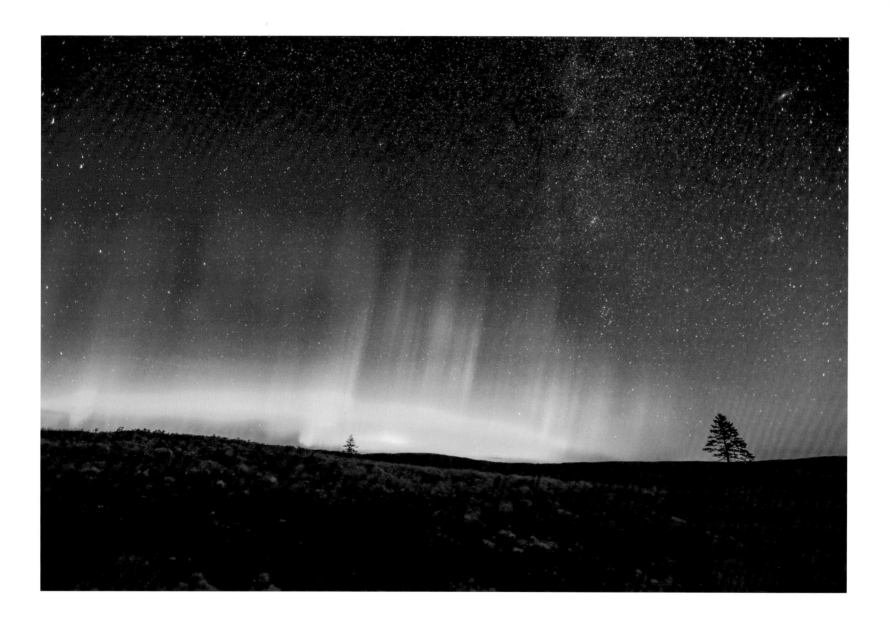

INTRODUCTION

STANDING ON A DIRT ROAD, I STRAIN MY EYES TO SEE IF THE light show has started. After half an hour, my night vision has improved to a point where I can see the contours of the land and the outline of trees against the moonless sky.

It starts slowly; there is no sound.

At first, I think it's a spotlight, low beyond the horizon, shining a narrow beam upwards. Then, another and another. Colour starts to appear in the night sky, and reds, violets, and yellow waves of light move across, or in some cases, shimmer, like a waterfall. These are the aurora borealis, or the northern lights. Except I'm not standing in the Yukon, or Iqaluit, or Northern Quebec. I'm here, on a plateau of the Cobequid Mountains in Cumberland County, Nova Scotia.

It is spectacular.

The shutter clicks away and I see the images on my viewing screen. Colours that I don't see in the sky appear in my camera. People often say things like, "It didn't look like that when I saw it" or "You must have used a computer to get those colours." Both are valid in these days of computer-generated images, but this is not the case. As anyone who has stood out waiting for twilight knows, seeing the false dawn, or seeing the different shades of colour in meteorites, our human eyes don't do well at night.

The rods in our eyes help us see in the dark. They take a while to kick in but it is those rods that increase in sensitivity at night and help us see. The problem is, they only see black, white, and shades of grey. The cones are what distinguishes colour and they are relatively useless at night. The result is that our film, or sensor these days, captures things we are not seeing; thus, it did look like it does in the camera, you just didn't see it.

An almost full moon starts to rise, and as the reflected sunlight from the moon brightens the sky, the colours of the northern lights become overpowered and disappear. The show is over.

These days you can look on the back of the screen and have a pretty good idea that you have an image. Some of the images in the book were taken on film, some exposures over three hours long, trying to get the swirl of the stars on a moonless night.

There are several images of stars and constellations but this is not an astrophotography book. There are groups and individuals who specialize and capture some amazing pictures using telescopes, cameras, and science. I don't have that skill set.

I do have a sense of wonderment that keeps finding me outside at night trying to capture pictures that portray the feel of the night.

Growing up in the Annapolis Valley, I spent my early years living in a three-storey century-old farmhouse. I remember nights waking up during thunder and lightning storms, and moving my bed by a window to fall asleep watching the night sky. As I got older, I would spend time camping and watch the lightning light up the tent—or, in one case, lie in a sleeping bag and watch a storm roll across the Northumberland Strait, miles away, the lightning dancing from sky to ocean.

At some point in our history, we started lighting up our world—first with gas, and now electricity.

We have gone from using light when we need it, to lighting up our world whenever its dark.

Streetlights light up kilometres upon kilometres of highway where few walk. Buildings and communities keep lights on all the time. Phrases like light pollution enter our vocabulary and one has to travel a long way to find a clean night sky, one without man-made light.

In Nova Scotia, we are lucky to have a dark sky preserve at Kejimkujik National Park and National Historic Site. This is a place where light pollution is kept to a minimum and we get to see night skies like we have for thousands of years.

The stars have been used by civilizations all over the world, and are part of the story of the planet upon which we live. Some were used as origin stories, and the places people went when they passed from this life; others used them as important markers for agriculture through the year. Names like Worm, Flower, Strawberry, Sturgeon, Beaver, all signify different full moons for different times of the year with North American First Nations peoples. Long before there were apps, the understanding of the night sky was there.

Years ago, you would guess where the moon would rise or where the Milky Way would be. Today, I plug in my locations and can find out when, where, and at what angle the stars and moon will appear in the sky. I can plug in numbers and find out where I need to be for that 1.4 seconds the space station is going to transit the moon face.

While these things make it easier to capture special moments, the sense of wonderment never goes away.

Over the last twenty years, the availability of high-quality cameras and sensors have made it possible to capture images like never before. When we used film to capture those low-light situations, the images often became grainy when the light-gathering limitations were reached. Today, we have sensors that can capture an image in extreme low-light conditions. Photographing lightning bugs in a field in the Wentworth Valley at midnight is now possible. Seeing a whale surface and blow, and catching the spray is now possible. Capturing a person running across the street and getting the subtle colours in the street and murals is now possible. While technology has made that possible, film was just as good or even better in some situations. The stars creating a circle around the North Star as the earth rotates on its axis, was a three-and-a-half-hour exposure near in Kejimkujik National Park and National Historic Site, enough time to get one frame and then develop it in a few days and see if I needed to shoot it again. There was no instant gratification on these shoots.

Night photography isn't all about waiting for it to become dark, though.

Some of the most beautiful light we witness, whether we are on the waterfront in Sydney, or watching a fisher tie his boat up in Yarmouth, happens as day gives way to night.

The golden hour, before the sun goes down and after the sun comes up, bathes the earth in a warm golden glow, the blue light wave from the sun being filtered by the earth's atmosphere. This ends when the sun goes down, or after it rises too high above the horizon. The blue hour happens after the sun goes down but rays of light are still in the night sky; it brings forth night pictures that still have some outline and contrast between buildings, people, and the night sky. The rich cobalt and violet mix with the fading oranges before the dark night sky takes over.

Sailing from Boston to Halifax one summer, I had the midnight to 4 AM watch and remember climbing up the ladder, my eyes, accustomed to the dark, looking up the mast. It seemed as though the red light at the top of the mast was slicing holes into the night sky as the boat moved in the swell. On deck, nothing but the red glow of the navigation system eerily lit up the helmsman's face. The stars went from the ocean to the bow to the stern, and all around us.

This was truly a dark-sky preserve when capturing the heavens, and other objects moving in the sky. This is all about long exposures, still cameras, and feeling insignificant in the universe as you try to find constellations and individual stars.

When the night sky starts to give way to dawn, the hour before almost mirrors the twilight of the evening. Shooting the city waking up as the ferry starts its first run for the day, ships moving out of Halifax Harbour, the crescent moonlight losing ground to rays of light falling on the high cirrus clouds, as the beauty of the night starts to fade. Each time frame of the night sky has its own unique characteristics that can provide totally different images while shooting the exact same subject.

Another element of low-light images is having to visualize what will be there, not what is there. Shadows become lighter, highlights can become overexposed, and point light can cause movement in the frame. The ability to use long exposures where the film plane gathers light for five, ten, twenty, forty, hundreds of seconds means the image you see has not begun yet. The house against the night sky with the taillights of a car driving by, the plane landing at the airport, its tail fin visible but the rest of the plane only a few lights, trucks passing over the Seal Island Bridge in Cape Breton. All these demonstrate the ability to be creative with light and colours that don't exist in the day.

This creativity in how we celebrate the night is illustrated by people all over the province.

In Sherbrooke Village on our province's eastern shore, an entire historical town is lit by over twenty thousand lights for the holiday season. Opening night features thousands of people walking with candles and lanterns, the visceral feeling of warmth and community all around. On the other side of the province, on a Christmas tree made of lobster traps and buoys, the lights intermingle with the names of people lost, or working in the fishing industry. In the tiny community of Hantsport, people freeze milk cartons full of dye-coloured water and then come together to make an igloo, which is then lit from behind.

All of this is a celebration of both creativity and light. Both Sydney's Lumiere Festival and Halifax's Nocturne Festival bring tens of thousands of people out to see the creative blending of light and night with art.

From sitting around a campfire on a beach along the North Shore to a moonlight paddle out of Lower Prospect, the night, and all it brings, is celebrated year-round in our province.

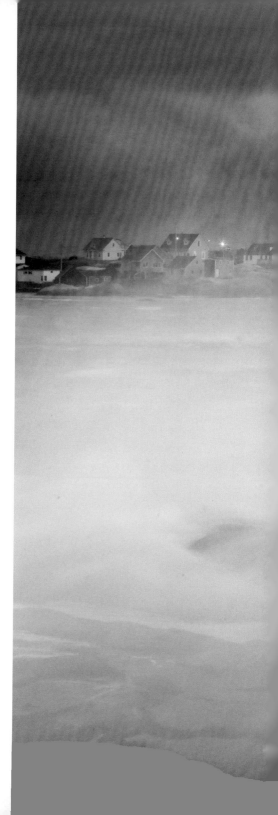

Waves crash against the granite shore in a long exposure as the light from Peggys Cove lighthouse serves as a beacon.

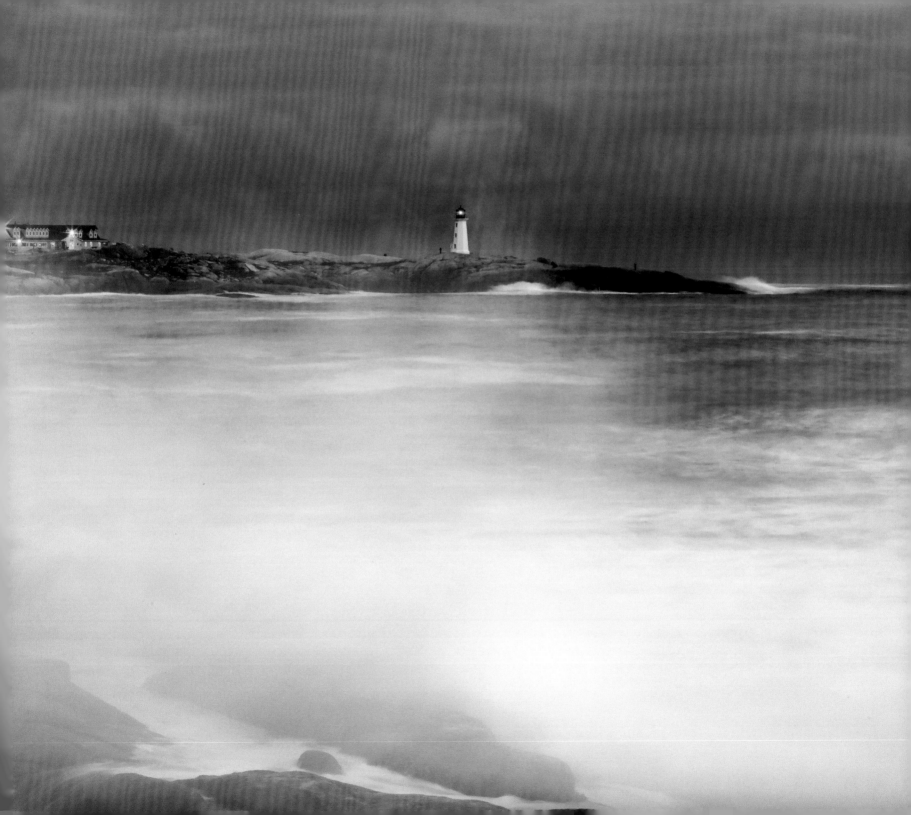

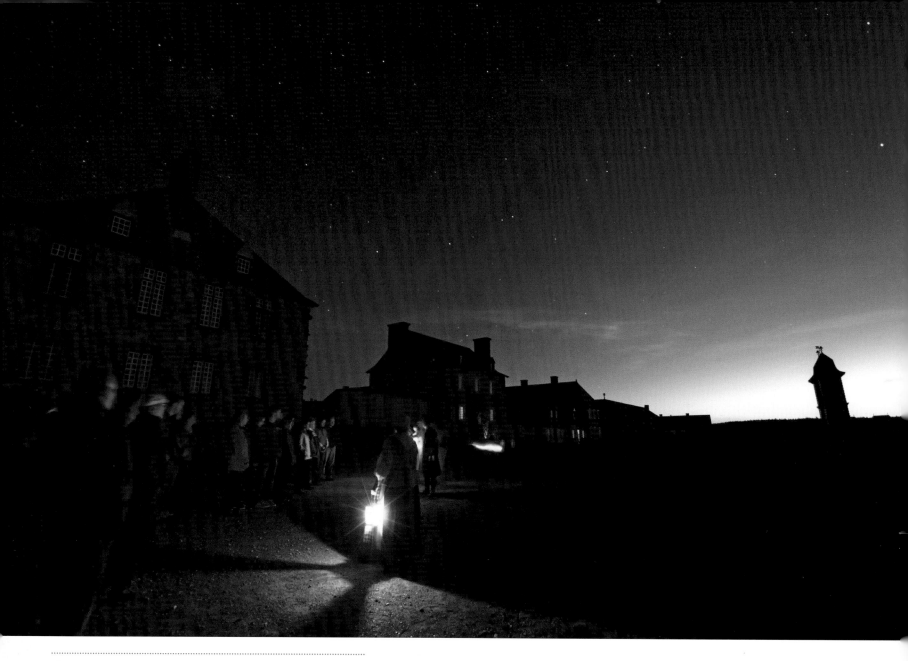

Visitors listen to tales of the night in the Fortress of Louisbourg on Cape Breton Island. The Parks Canada site has interpreters who take visitors through the streets and talk about the darker side of the city in the 1700s.

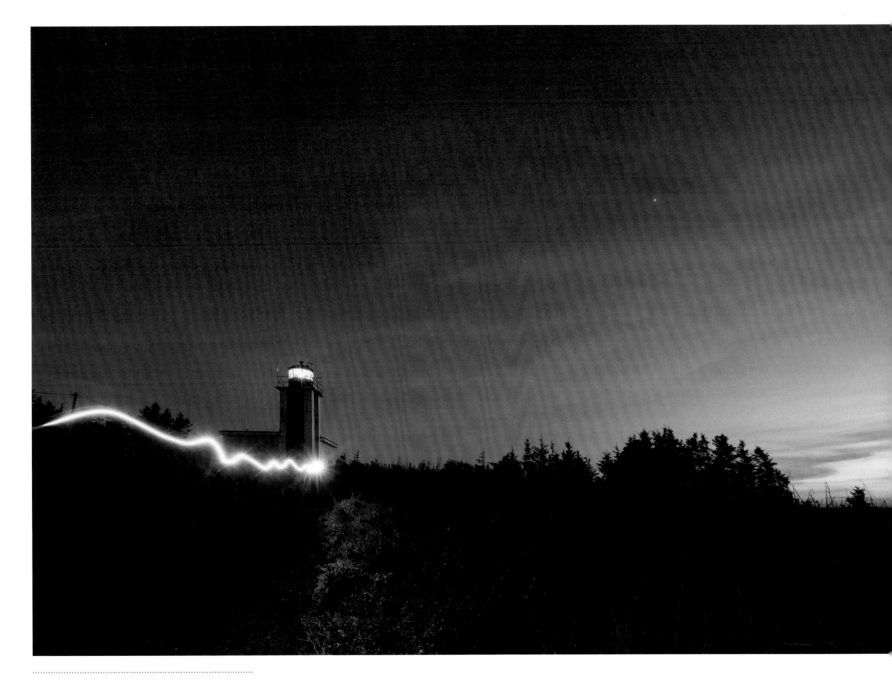

A hiker's flashlight illuminates the grass
at Point Prim lighthouse near Digby.

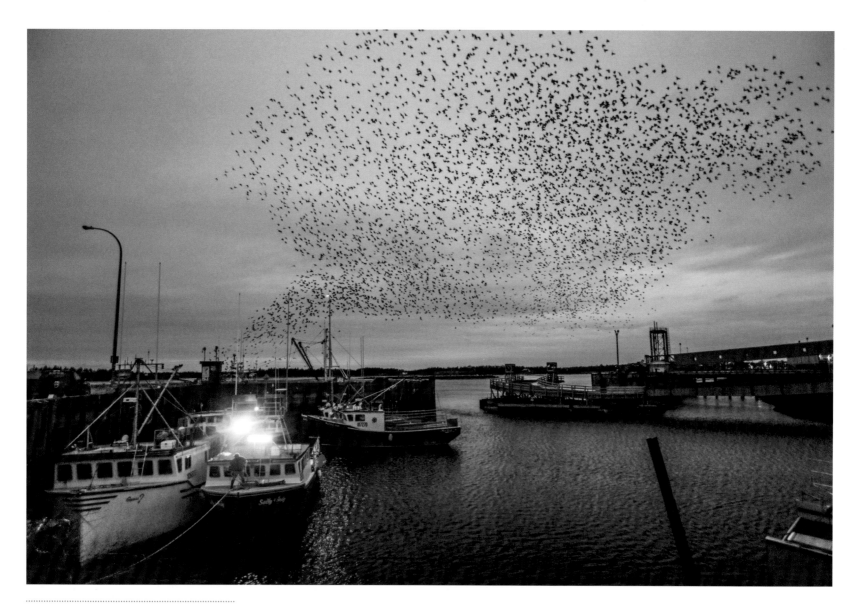

A fisherman secures his boat before a storm in Yarmouth Harbour while a murmuration of starlings flies above. A murmuration occurs when birds move as one in an ever-changing pattern.

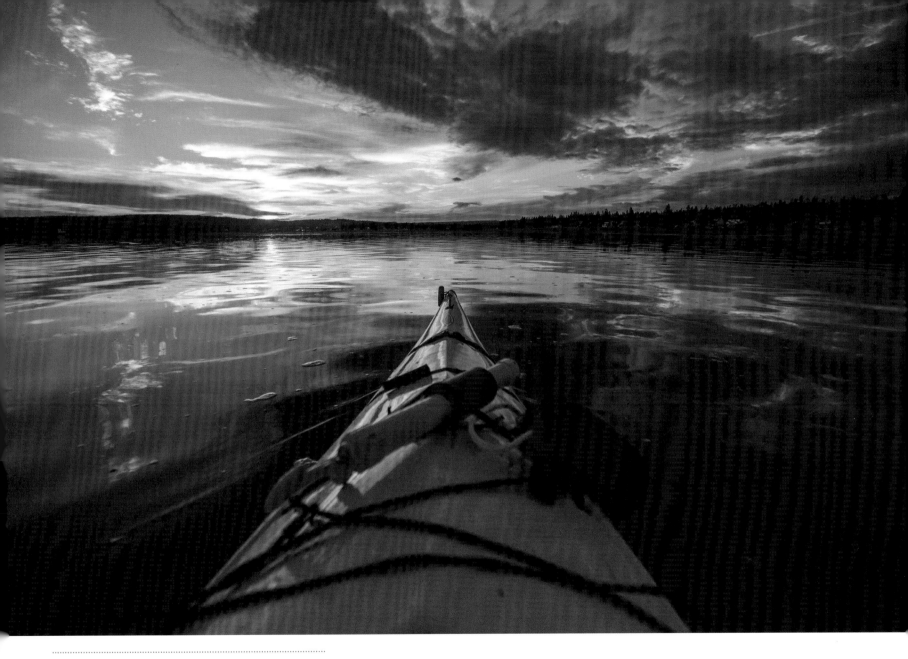

The bow of a kayak picks up the last rays of the setting sun on a calm Bay of Fundy.

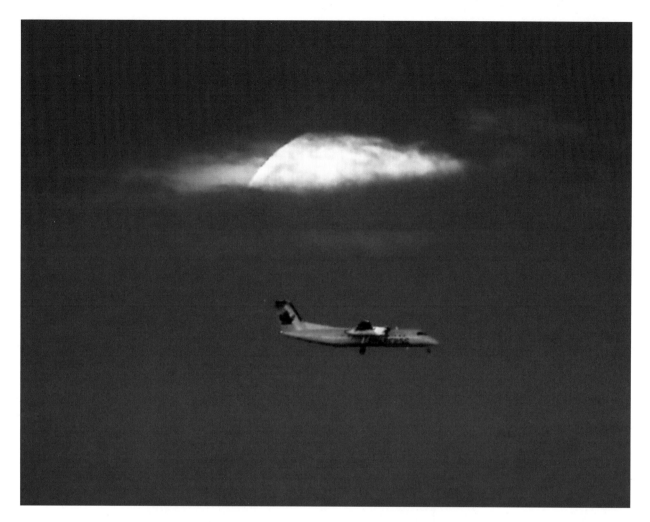

Left: An Air Canada plane makes its final approach to Halifax's Stanfield International Airport with a full moon obscured by clouds behind it.

Below: The International Space Station, 250 kilometers above earth, crosses the face of the moon. The solar panels extended, it is the white dot moving from left to right in the images. Travelling at approximately 17,150 miles per hour, the entire traverse took 1.5 seconds in the camera frame.

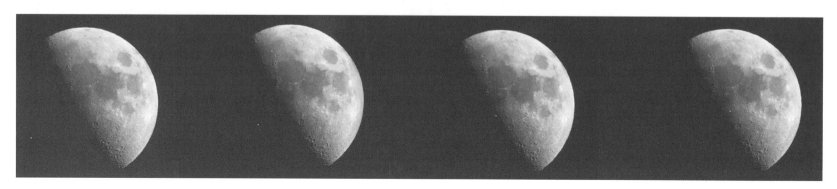

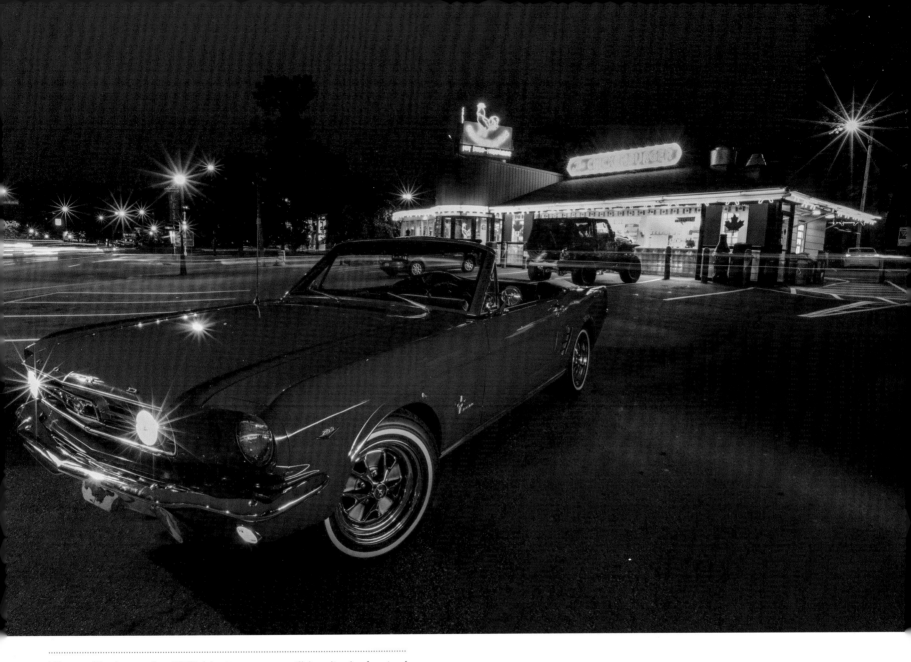

Wayne Blackwood's 1966 Mustang convertible sits in front of the Chickenburger in Bedford, Nova Scotia. A stopping place since the 1940s, the restaurant is a common gathering place for people who have classic cars. Alan Blackwood stops in with his father's car, restored in the '90s but looking like new.

11

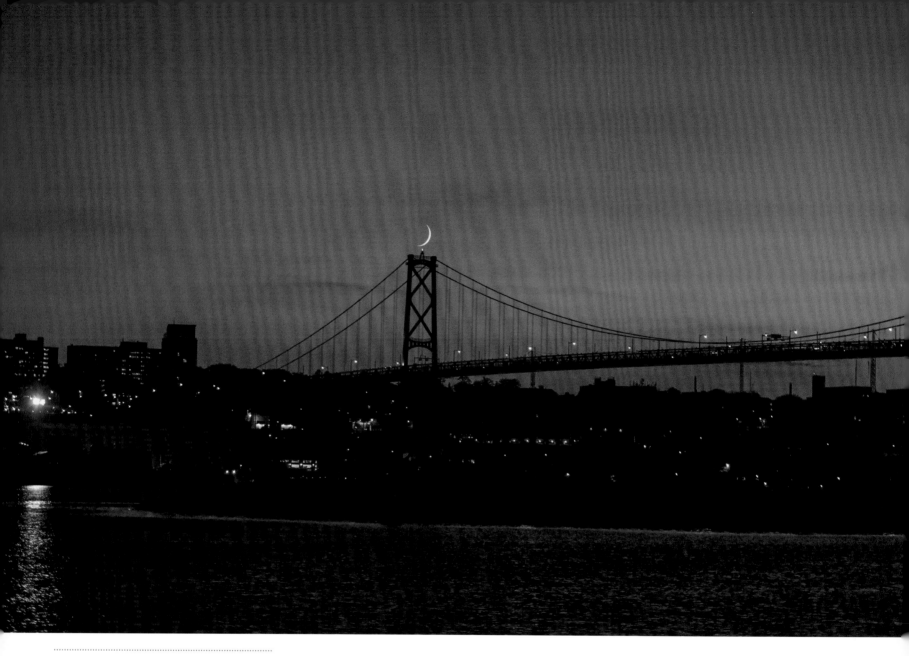

A crescent moon seems to balance on
the top of the Angus L. Macdonald Bridge
connecting Halifax and Dartmouth.

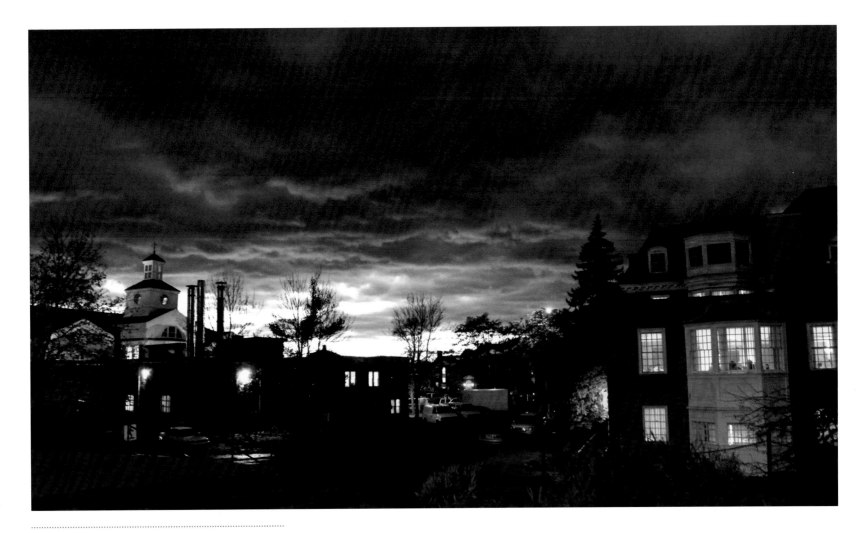

Twilight sets in on St. Francis Xavier University in Antigonish. The university, founded in 1853, is home to the world-renowned X ring that graduates receive.

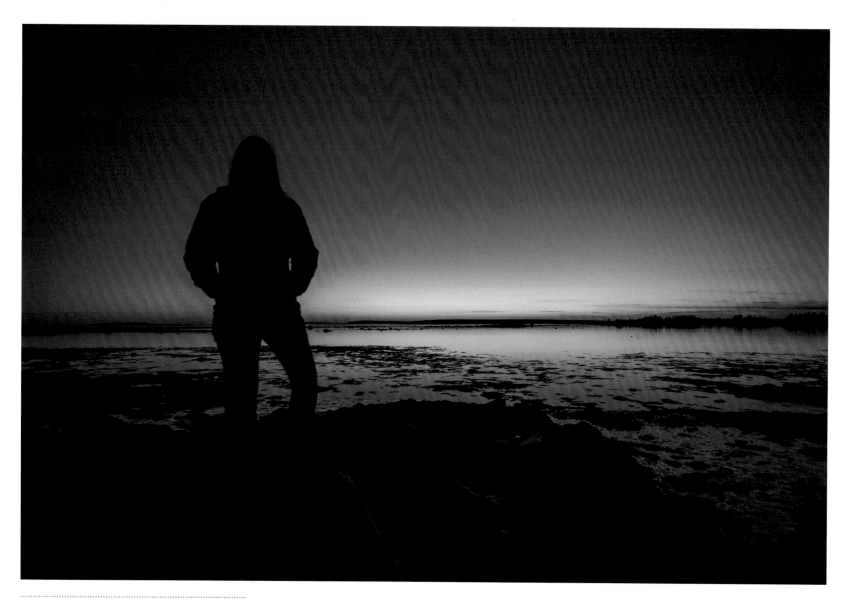

A young woman takes in the stillness of
the evening while twilight descends over
the Atlantic Ocean near Pubnico.

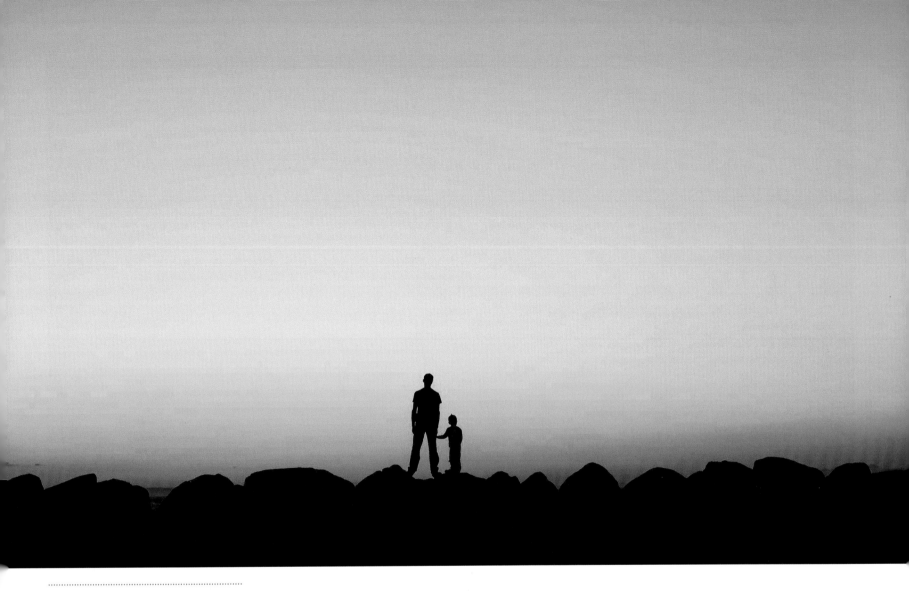

A father and son enjoy nature's light show as the sun goes down near Halls Harbour.

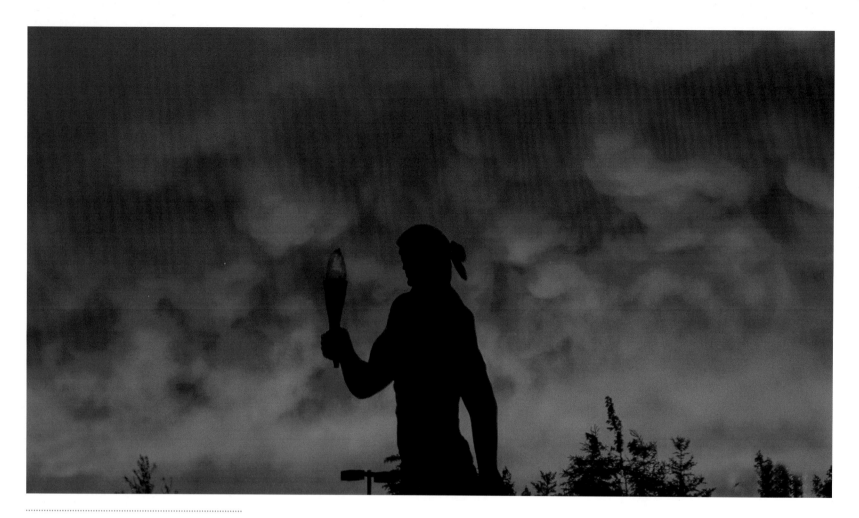

The statue of Glooscap, the Mi'kmaw god of creation, is silhouetted against a blazing orange sky as the sun goes down. The twelve-metre statue is a familiar site to travellers along Highway 102 near Truro.

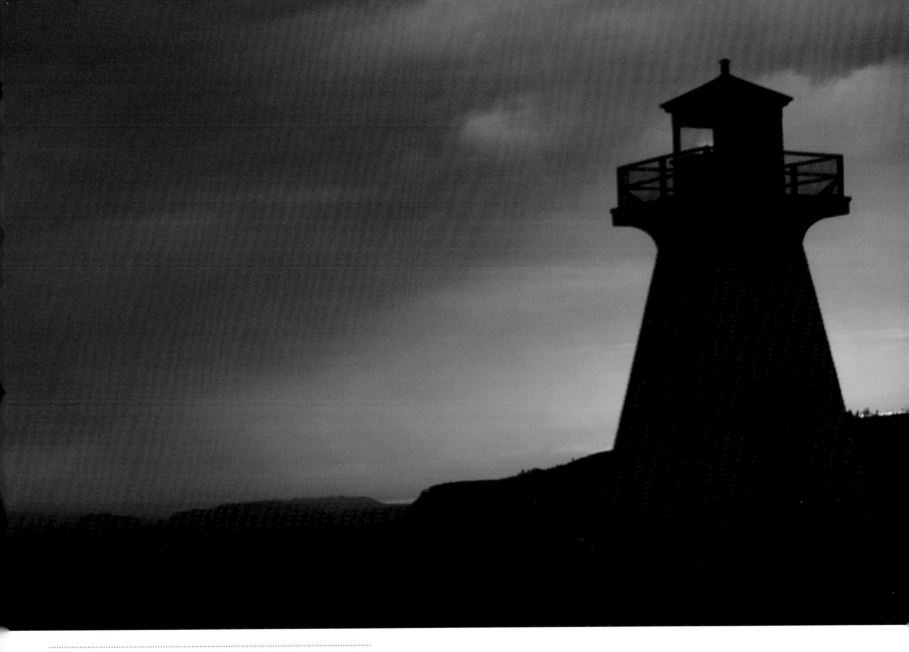

A lighthouse overlooks the Five Islands. Once a necessity of every harbour in the province, lighthouses have become almost obsolete with today's satellite-navigation systems. Part of our cultural fabric, some have been maintained by communities even when they are no longer active.

Below: A lone fisherman, bathed in an orange glow from the setting sun, casts his line into the Bay of Fundy in Highland Village.

Opposite: A clam harvester makes his way to shore along the beach near Five Islands.

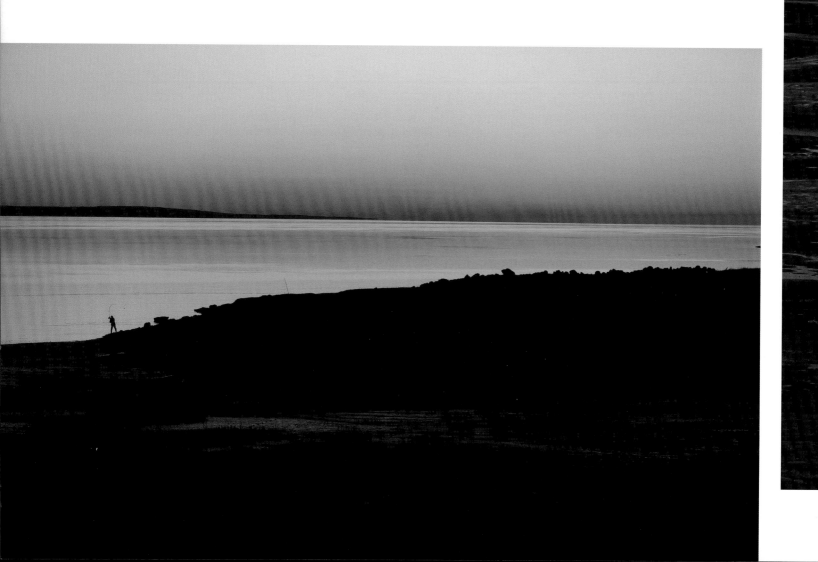

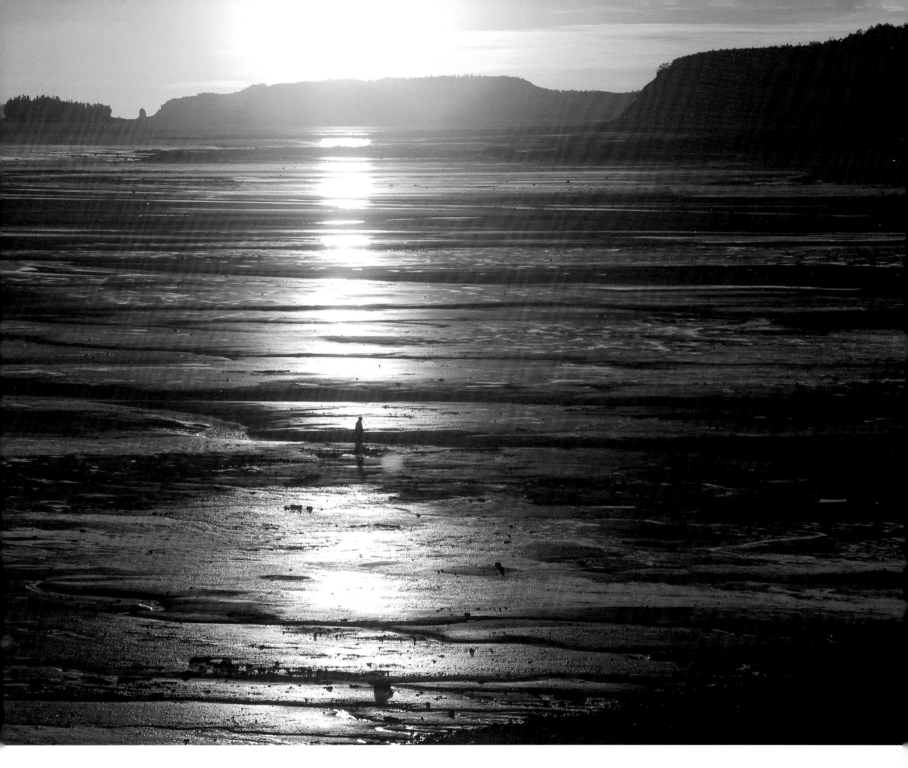

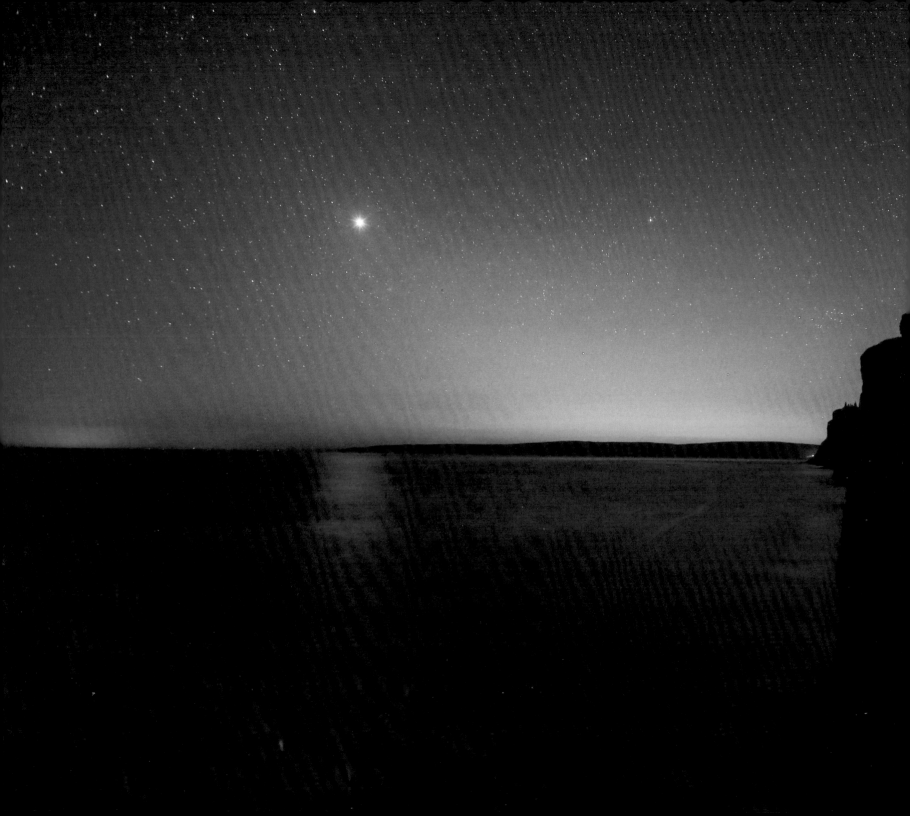

Venus shines bright in the sky over Advocate Harbour along the Bay of Fundy.

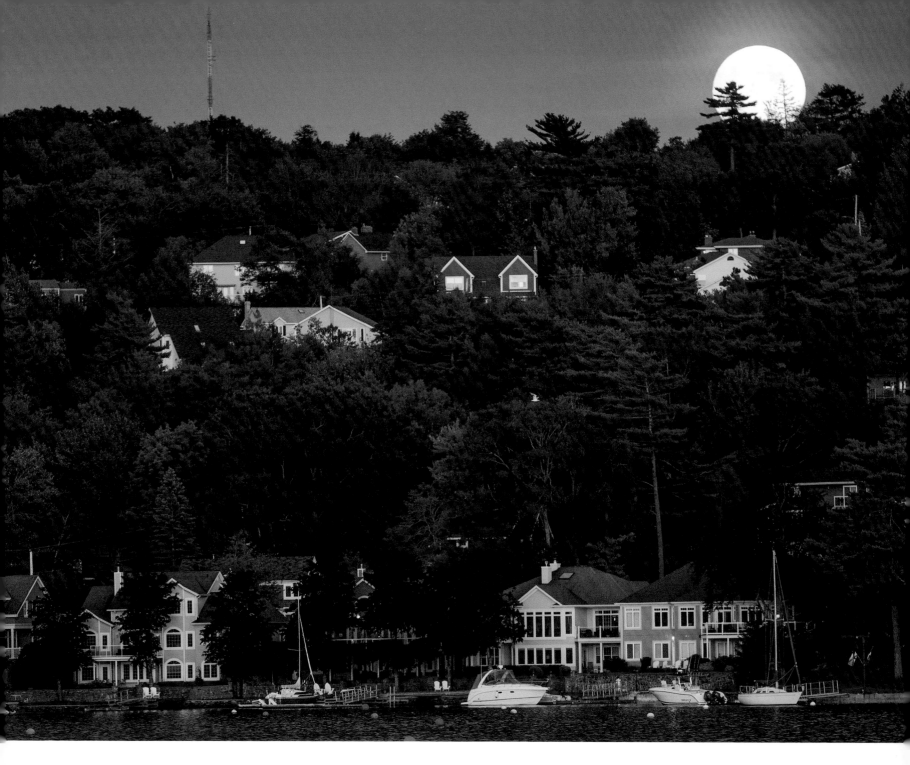

Opposite: Sailboats at their moorings in Bedford Basin as the full moon rises over Bedford.

Below: Cars whiz by while the photographer looks up George and Carmichael Streets towards the Town Clock in Halifax.

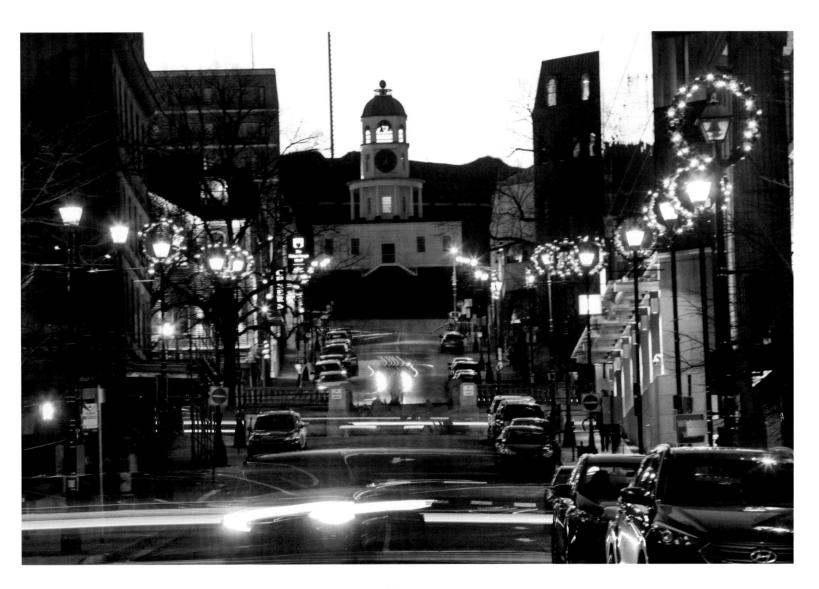

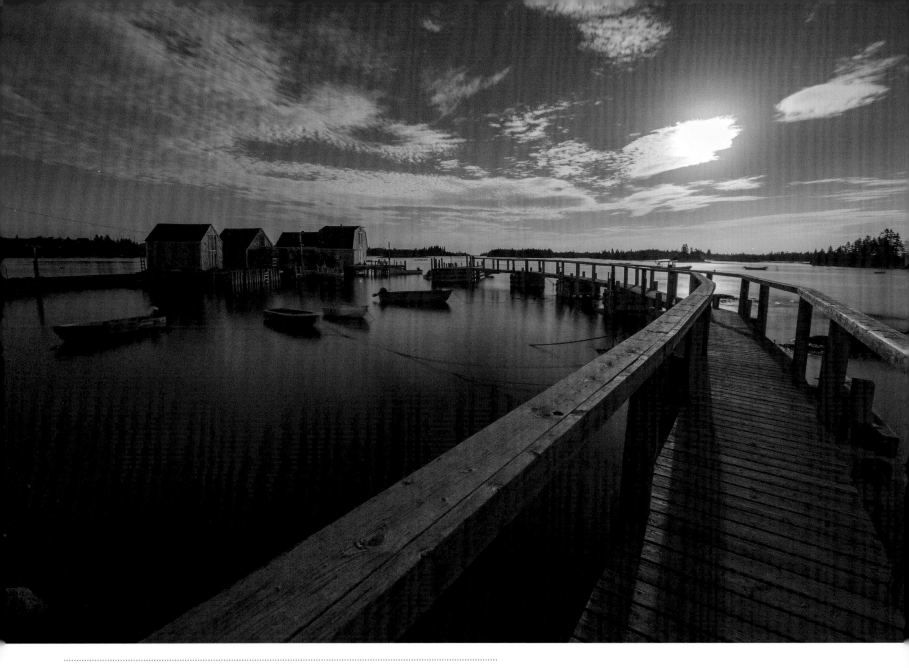

Just outside Lunenburg is a quaint spot named Blue Rocks because of the colour of the rocks in the area. This image, taken near midnight under a full moon, appears to be daylight. The movement of the boats and the stars in the sky are the only things giving it away.

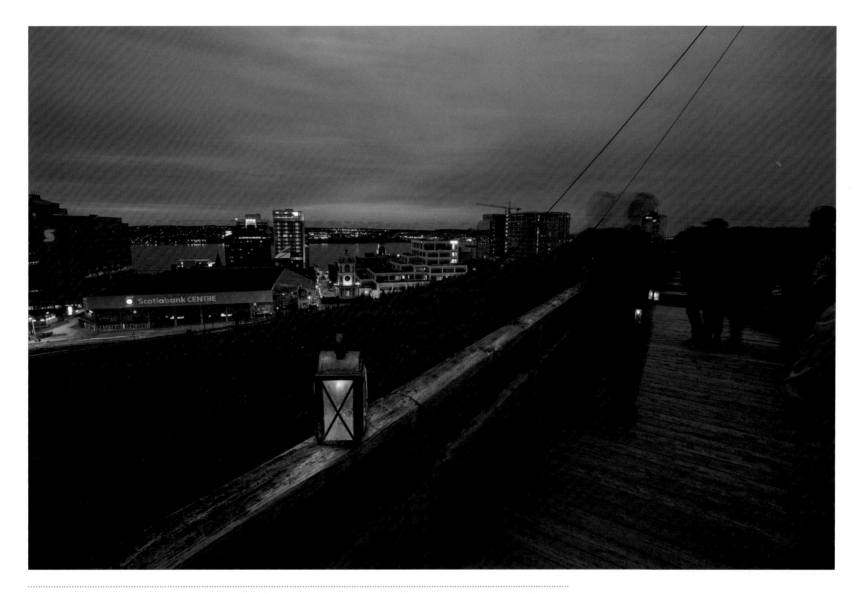

Above: Located on top of a hill, the Halifax Citadel National Historic Site was built when the city was founded in 1749. Here, a guide talks to a tour group from the top of a rampart.

Next spread: Lights glow from the main lodge at White Point Beach Resort as the waves from an incoming tide spill over the sand. Since 1928, White Point, with its boating, surfing, golfing, and food and entertainment, has been a cornerstone of tourism on Nova Scotia's south shore.

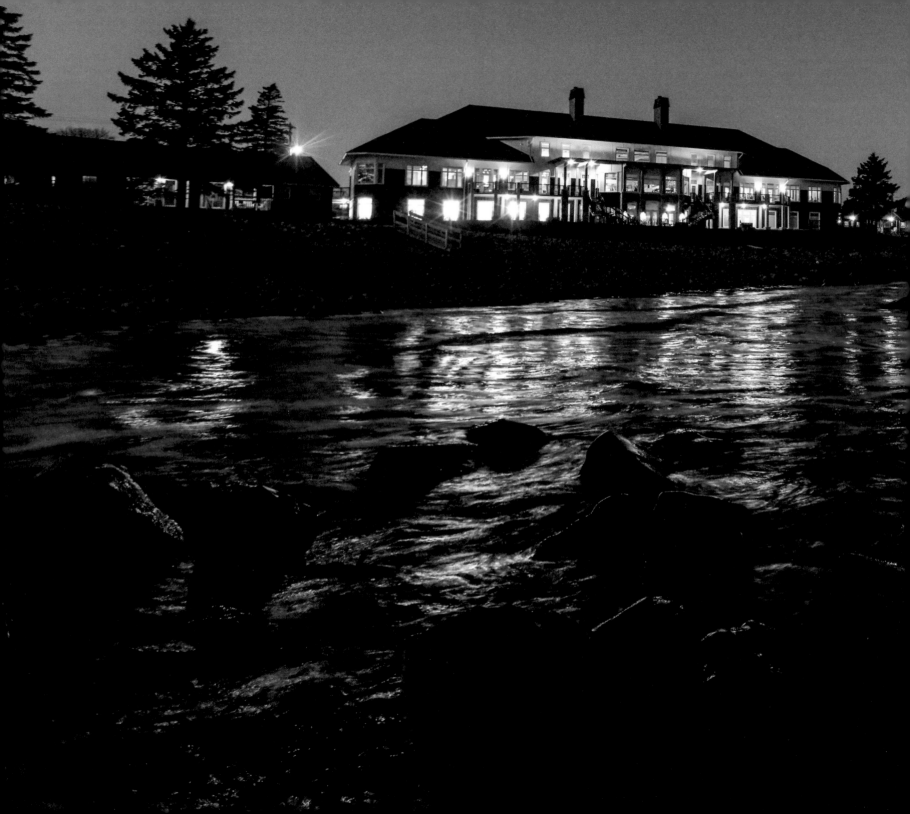

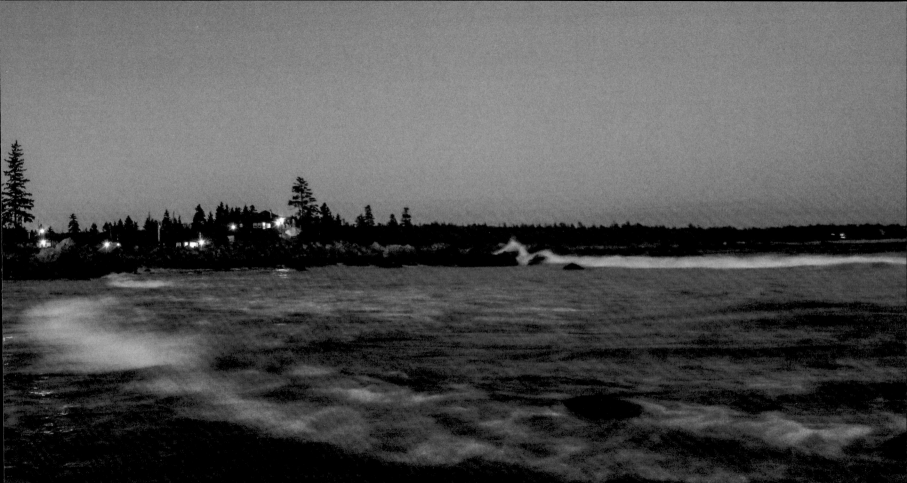

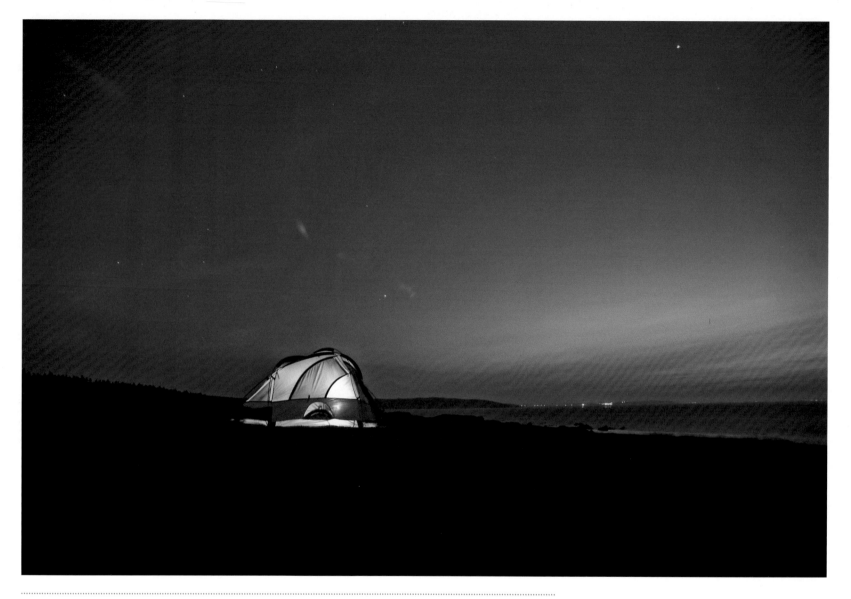

Above: The stars start to appear over a lone tent on Scatarie Island off the coast of Cape Breton.

Opposite: The International Space Station soars over Peggys Cove lighthouse on a clear February evening. The station's reflective solar panels, seen as a bright star that moves across the film plane, cause the streak of white light when the shutter is held open.

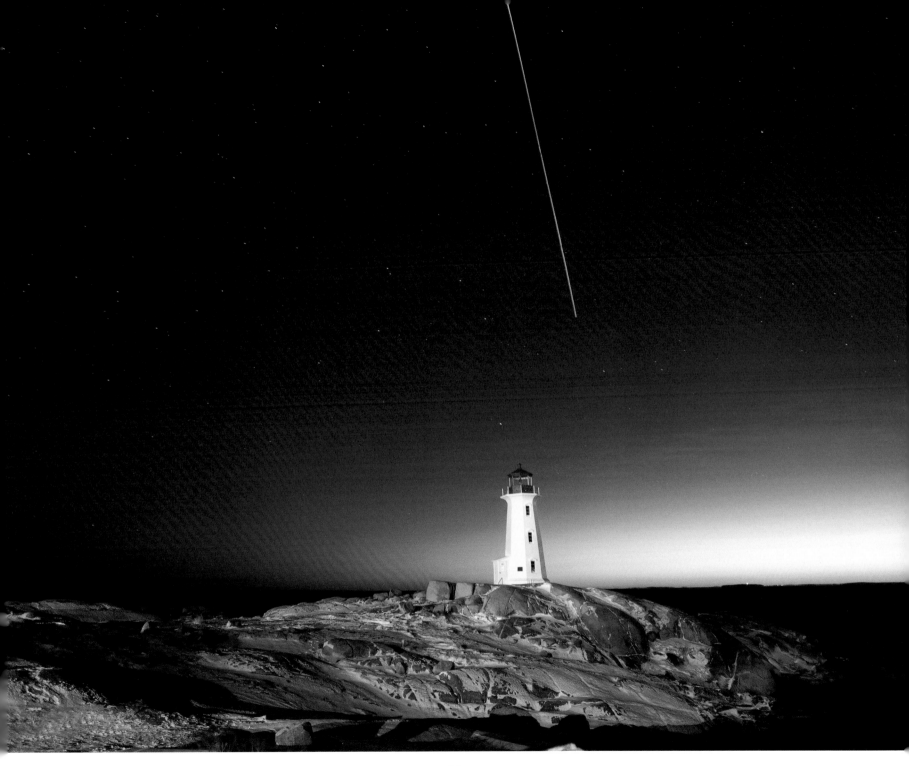

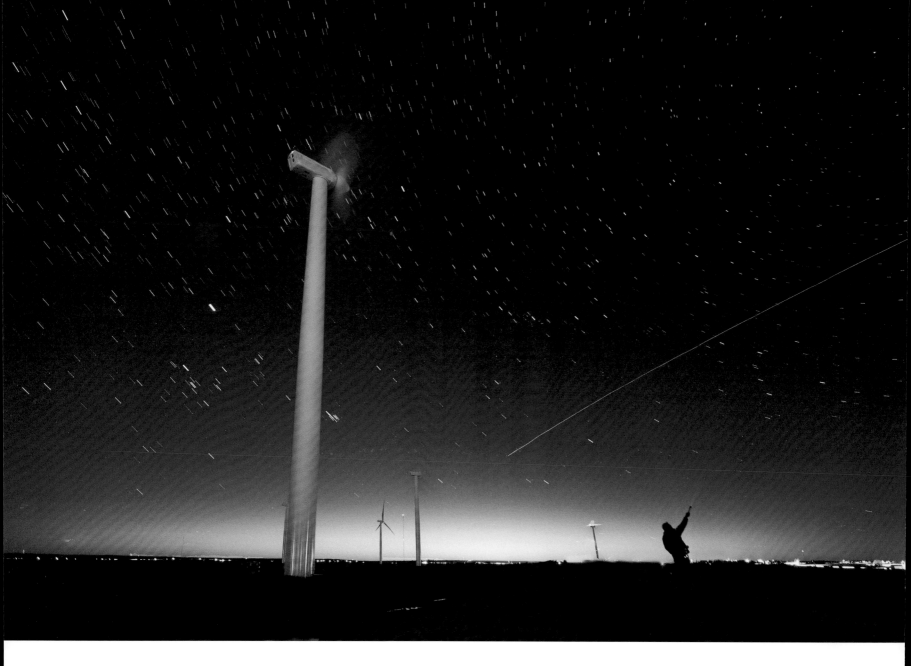

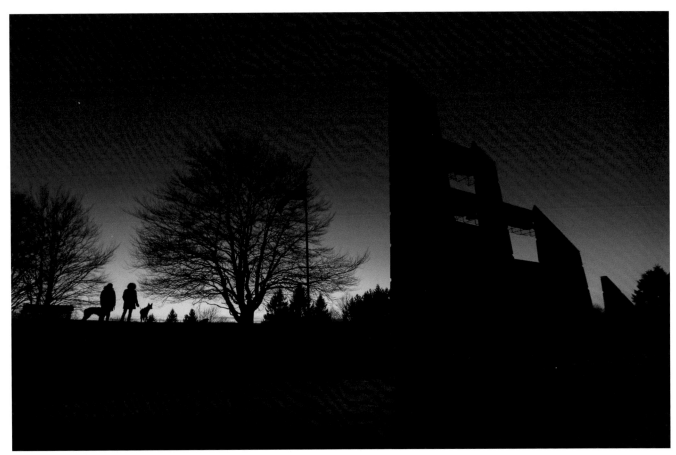

Opposite: The blades of a turbine seem to spin fast in this multiple long-exposure photograph in a field near Amherst. The winds of the Tantramar Marsh proved to be an ideal spot for a wind farm. On this night, the International Space Station, the long white streak of light, as well as a meteor, far right, made appearances.

Above: Friends stop and enjoy the twilight at Fort Needham Memorial Park in Halifax. The park's bell tower commemorates the Halifax Explosion that occurred when a relief ship and a munitions ship collided in the Narrows below. In total, over two thousand people were killed and another nine thousand were injured in the December 6, 1917, explosion.

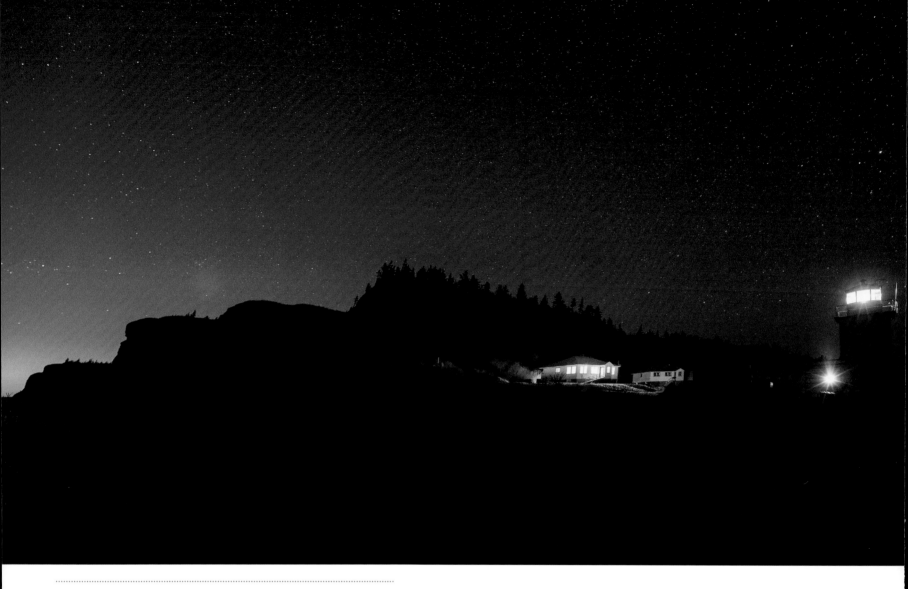

Above: Light from the lighthouse at Cap d'Or and the old
lightkeeper's residence spill into the night sky near Advocate
Harbour. The lighthouse bears witness to billions of tonnes of
water churning by as the Bay of Fundy fills and empties with
the volume of all the freshwater rivers in the world.

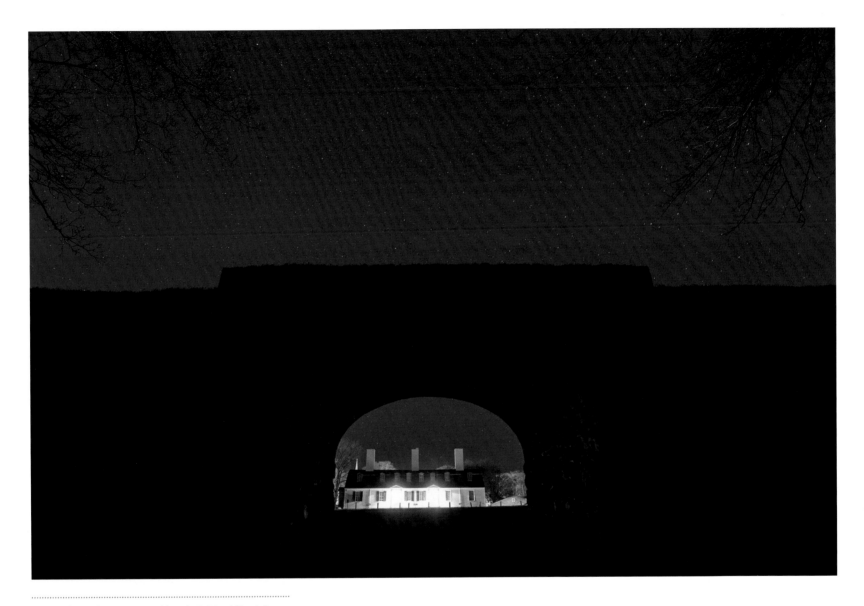

The officers' quarters shine bright at Fort Anne National Historic Site in Annapolis Royal. First built by the Scottish in 1629, the fort changed hands as European wars spilled into North America. In 1917 it became the first operational national historic site in the country.

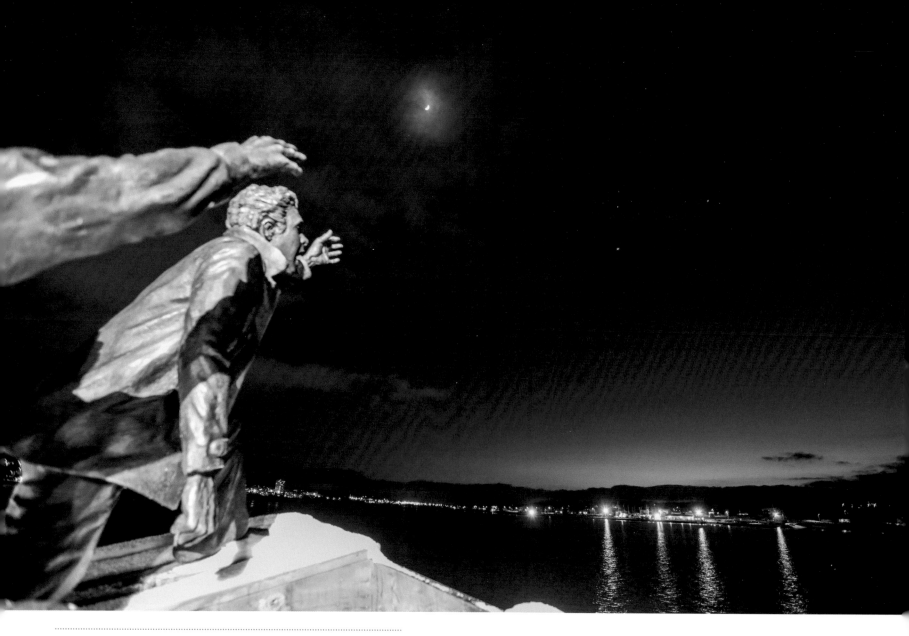

Sailors of the merchant-navy sculpture appear to be reaching for the stars along the waterfront in Sydney. The monument is a tribute to the thousands of merchant marine sailors who risked their lives in the Second World War, when Nova Scotia was a jumping-off point for convoys, bringing goods and supplies to Europe.

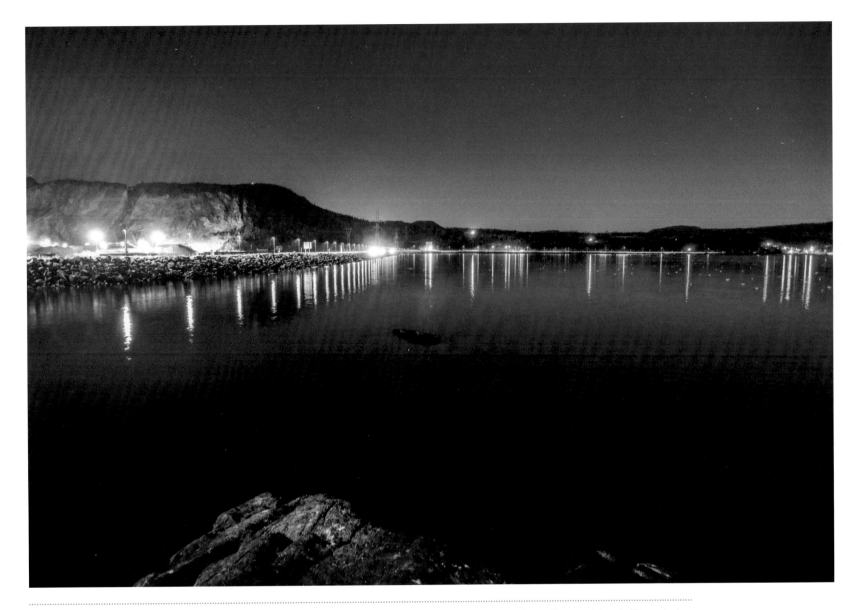

Above: A humpback whale spout is illuminated by the lights of the Canso Causeway from Cape Breton Island. The whales spent time near the causeway feeding on schools of fish in the area, presenting viewers with spectacular scenes.

Next spread: The three churches on the waterfront of Mahone Bay, (left to right) St. James Anglican Church, St. John's Lutheran Church, and Trinity United Church, are a must-see spot along the province's south shore.

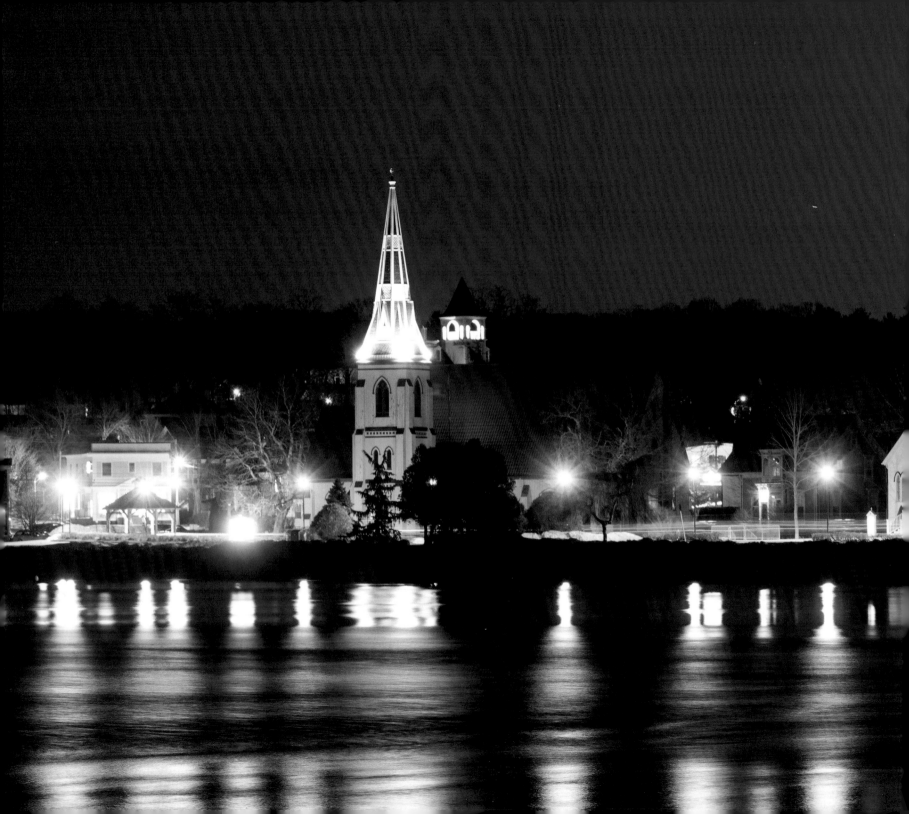

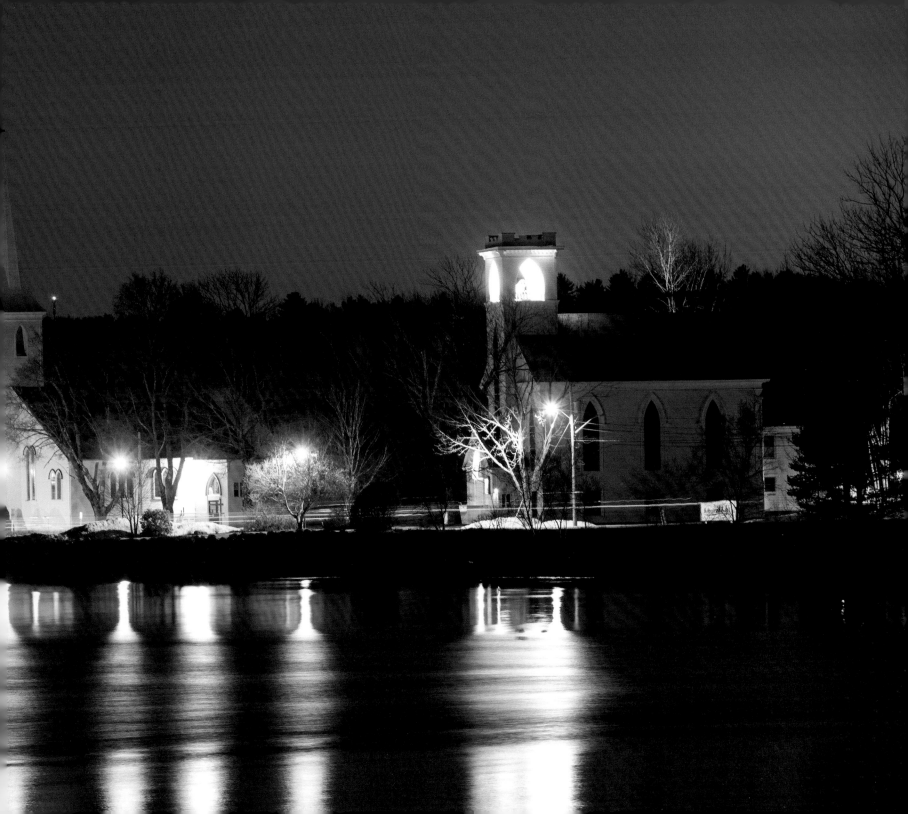

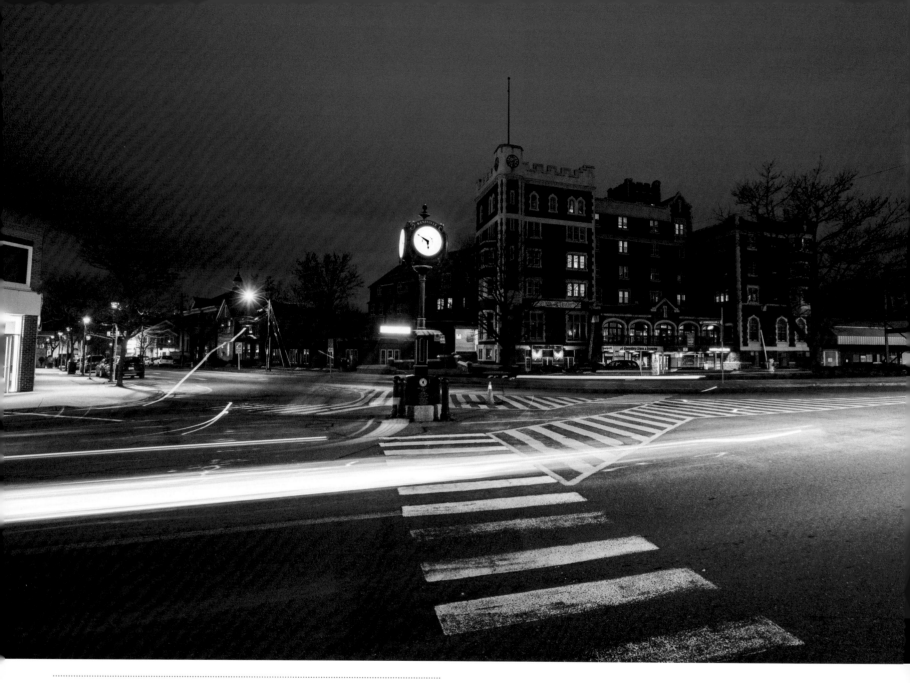

Cars pass the town clock in Kentville that was erected in 2011 to celebrate the town's 125th anniversary. The Cornwallis Inn (right), built in 1930, is no longer an inn but a mix of apartments and businesses.

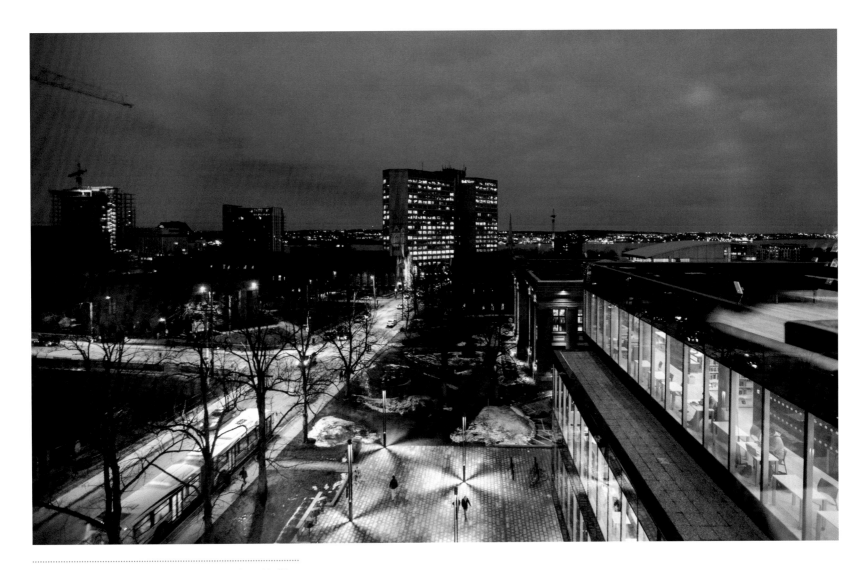

Pedestrians make their way to the Halifax Central Library. Opened in 2014, the library, with its award-winning design, draws thousands of visitors every day.

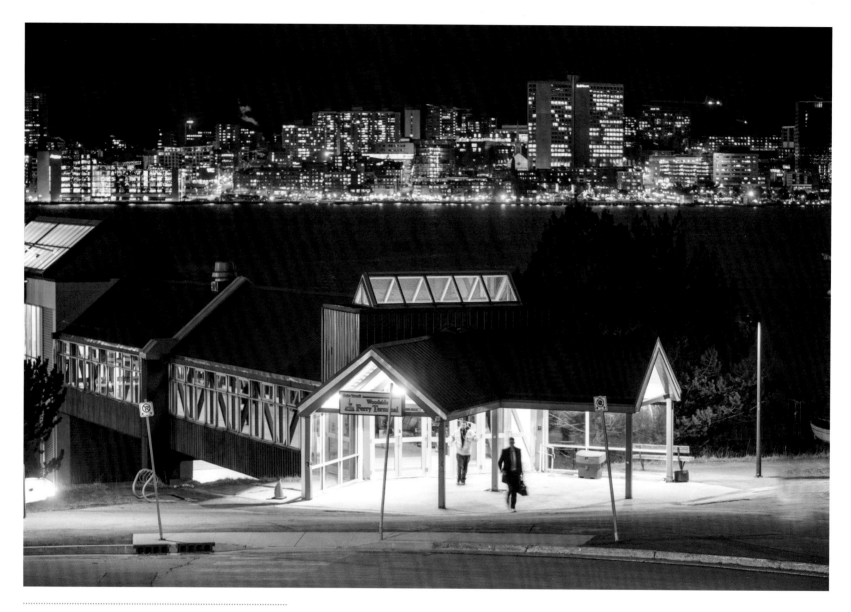

A commuter hurries out of the Halifax Transit ferry terminal in Woodside. The ferry service across Halifax Harbour started in 1752 and today carries thousands of people a day.

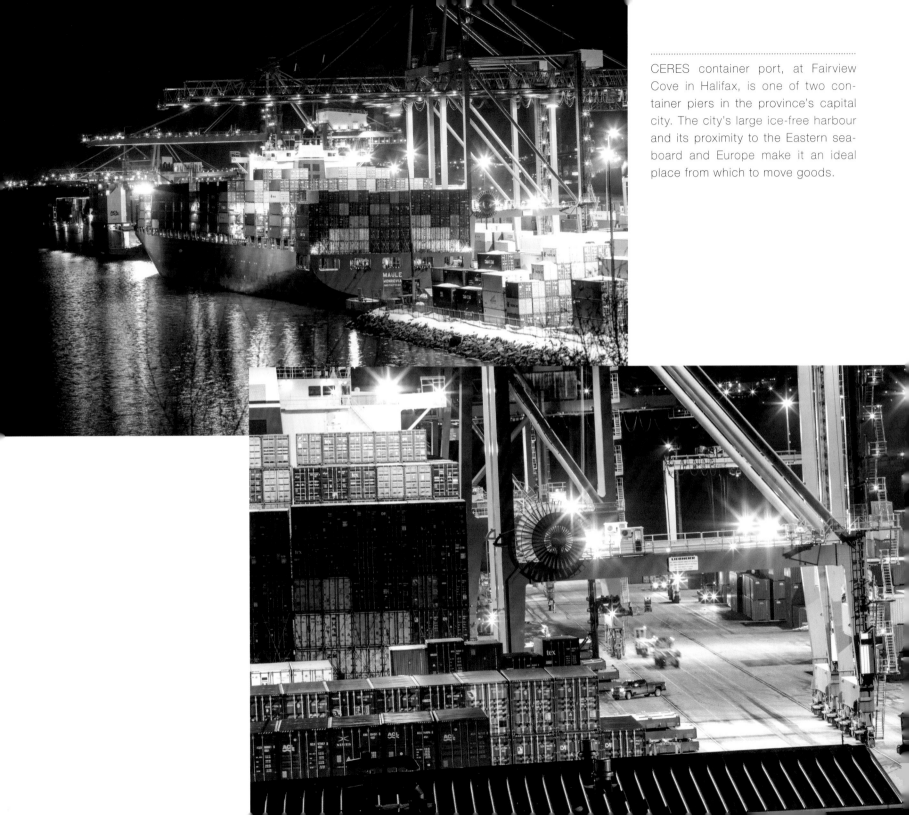

CERES container port, at Fairview Cove in Halifax, is one of two container piers in the province's capital city. The city's large ice-free harbour and its proximity to the Eastern seaboard and Europe make it an ideal place from which to move goods.

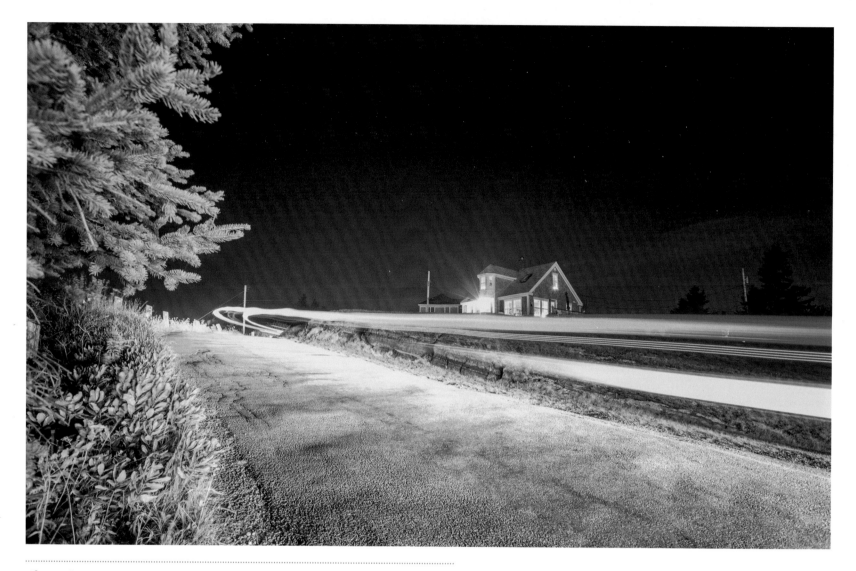

Above: A car's tail lights leave light trails as it passes a home in rural Nova Scotia. Above the house, the Big Dipper, or Great Bear, constellation is visible.

Opposite: Located on top of the hill on the peninsula of Halifax, the Halifax Citadel National Historic Site was built when the city was founded in 1749. At times throughout the year visitors can partake in a guided night tour complete with scary stories of ghosts and evil deeds.

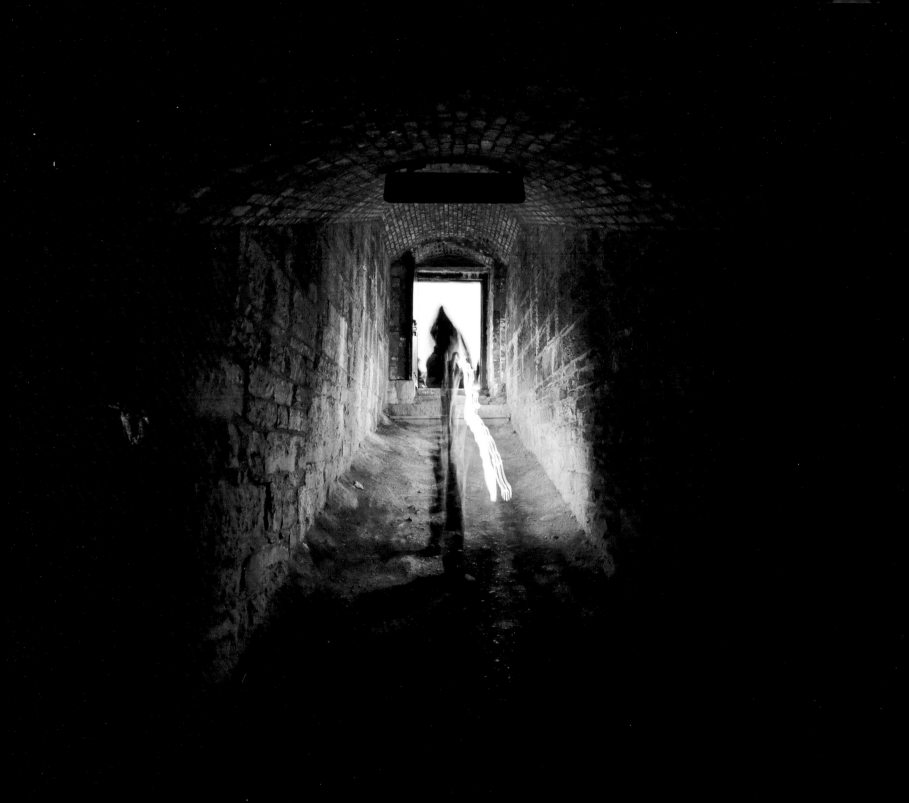

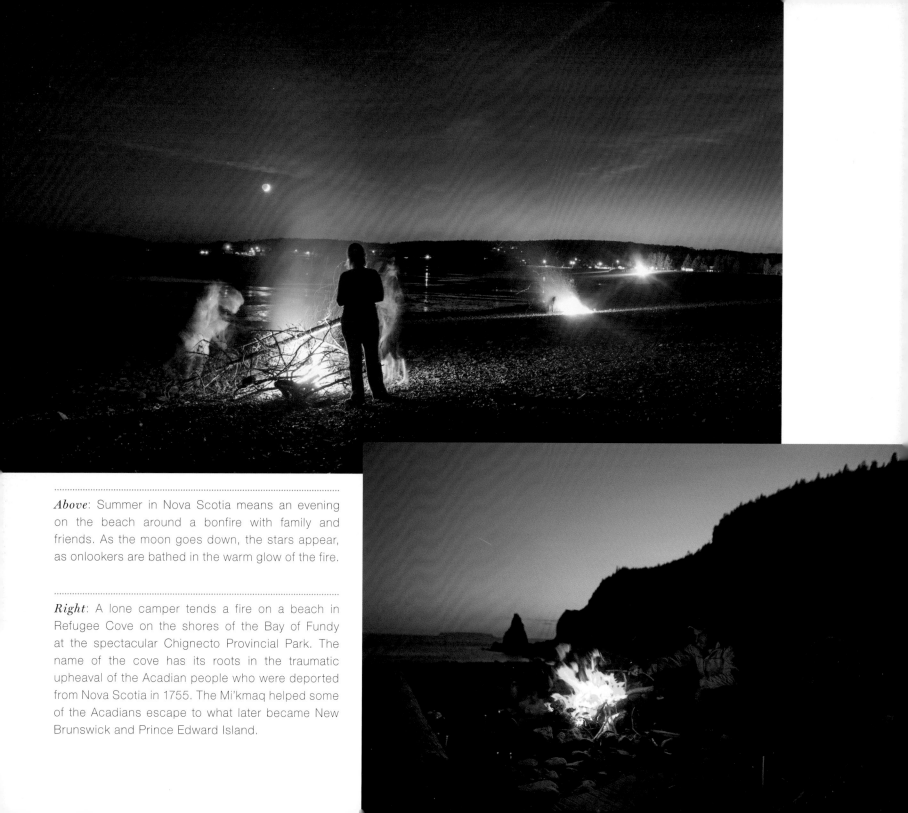

Above: Summer in Nova Scotia means an evening on the beach around a bonfire with family and friends. As the moon goes down, the stars appear, as onlookers are bathed in the warm glow of the fire.

Right: A lone camper tends a fire on a beach in Refugee Cove on the shores of the Bay of Fundy at the spectacular Chignecto Provincial Park. The name of the cove has its roots in the traumatic upheaval of the Acadian people who were deported from Nova Scotia in 1755. The Mi'kmaq helped some of the Acadians escape to what later became New Brunswick and Prince Edward Island.

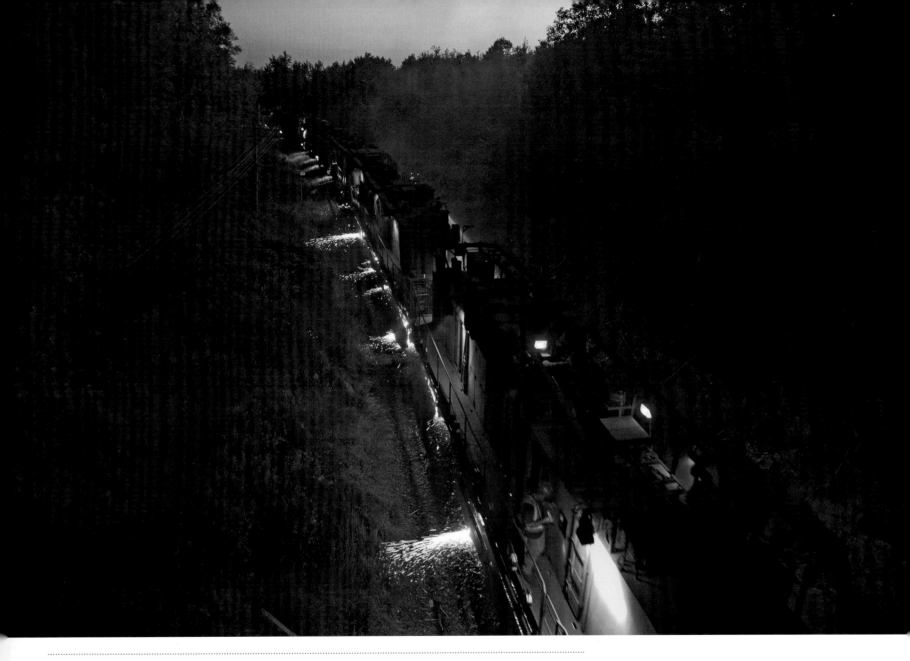

A worker checks controls on a maintenance train on the main railway line between Halifax and Truro. The sparks are from the grinders evening out the steel rails.

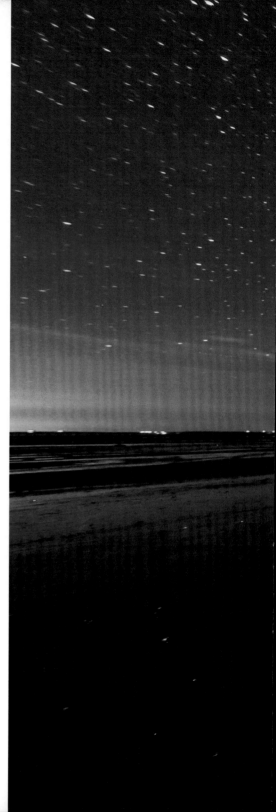

The Milky Way reflects off the floor of the ocean in the Bay of Fundy. With the world's highest tides, recorded at over fifty feet at Burntcoat Head, the ocean floor is exposed twice a day in parts of the Fundy coast.

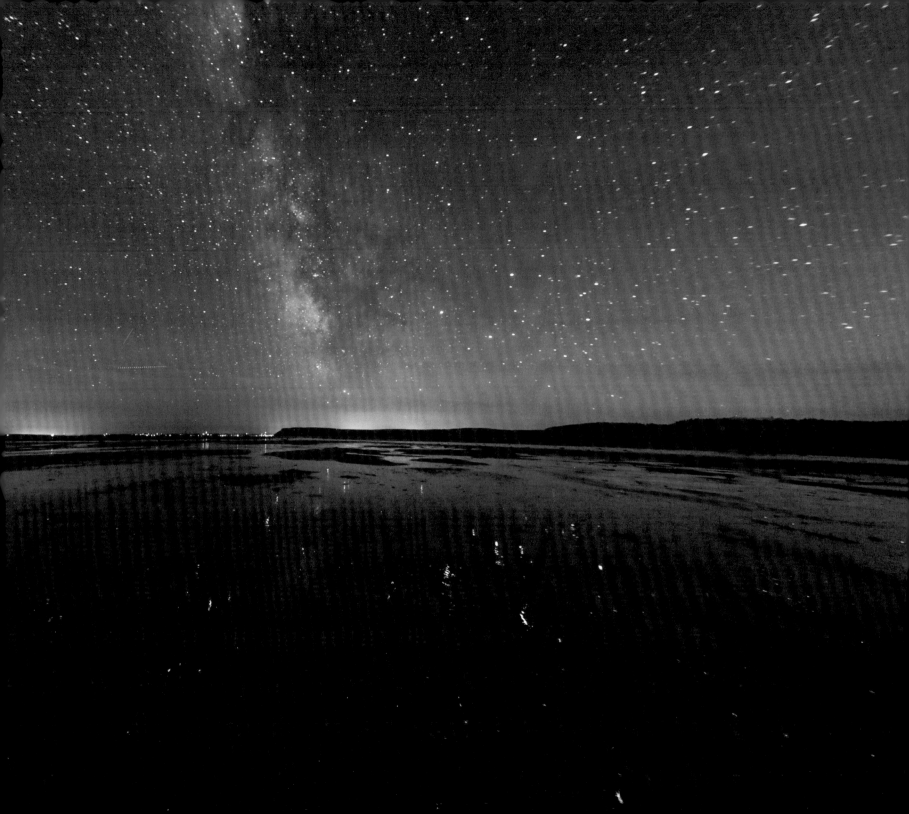

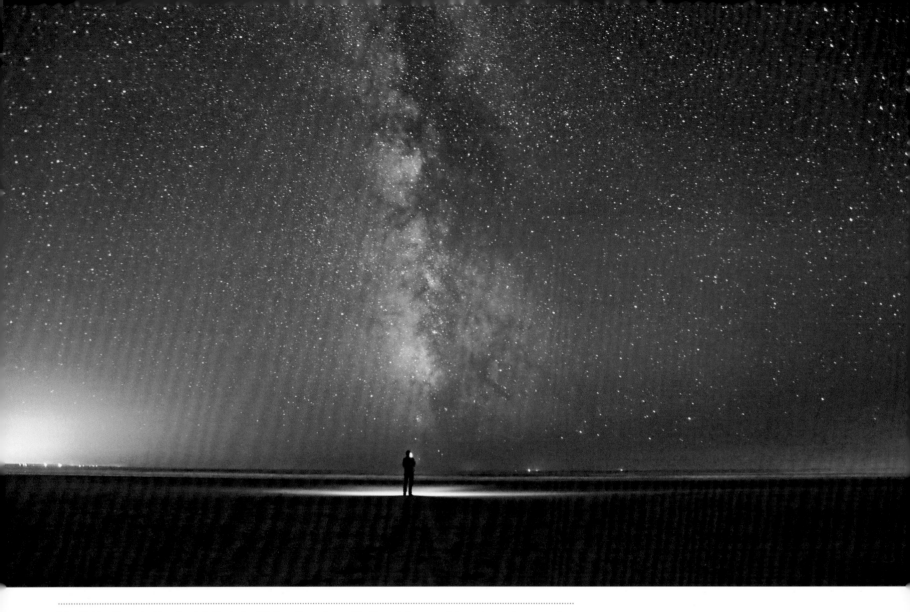

Mavilette Beach Provincial Park in Digby County, with its white sand beach and sweeping dunes, is an amazing place to walk or sit and watch the stars.

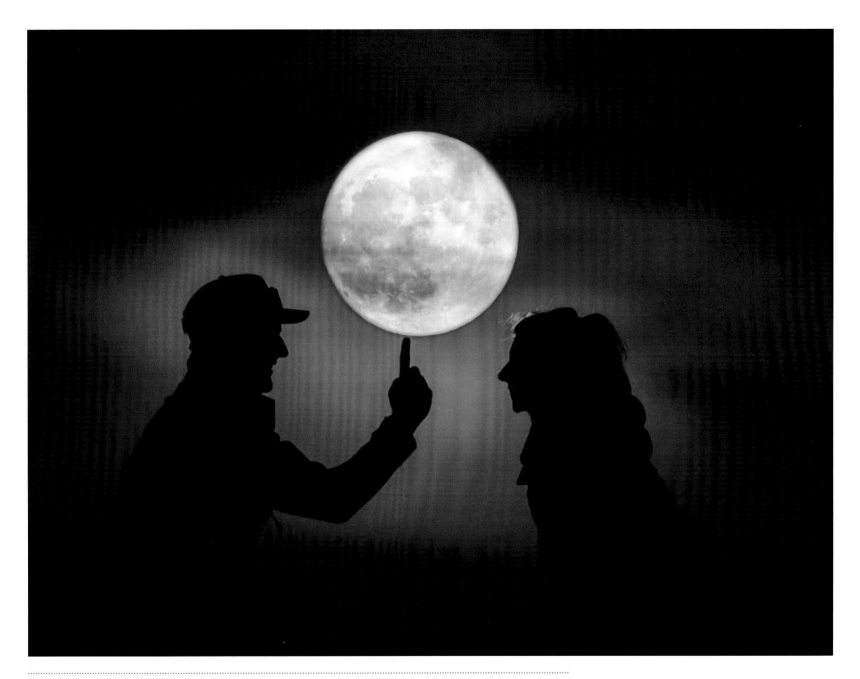

A couple have some fun while posing in front of a full moon in Enfield. The November 14, 2016, moon was the biggest and brightest in more than sixty years.

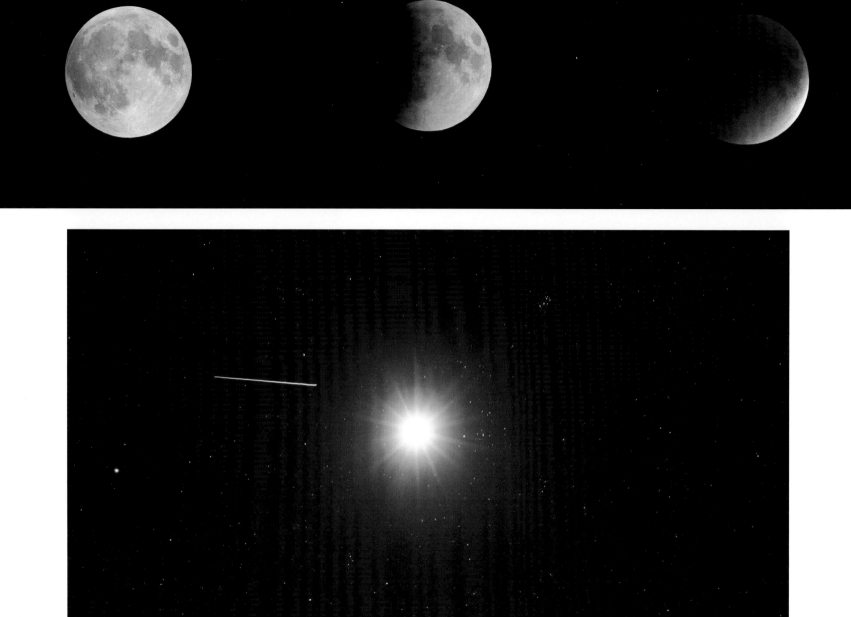

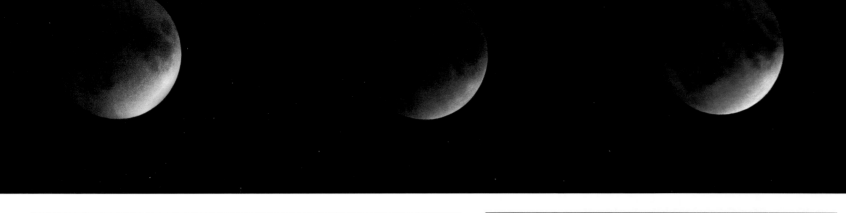

Above: Stages of the total lunar eclipse of the full moon on September 27, 2015. This phenomena is also known as a blood moon because the moon takes on a red colour as it passes through the earth's shadow.

Opposite: The International Space Station appears as a line as it crosses near a full moon. The white line is a reflection of the station's solar panels and it moves across the camera's sensor.

Right: A plane bound for the United States's east coast passes in front of the moon.

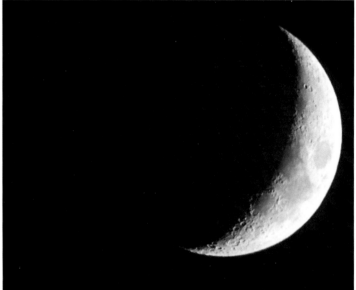

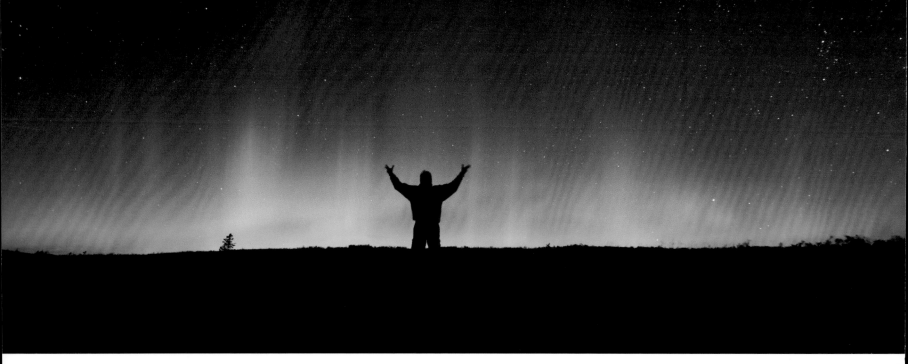

Lights from the aurora borealis shimmer in the night sky along the Cobequid Mountains in northern Nova Scotia. The lights, referred to sometimes as the northern lights, occur when charged particles from the sun collide with the earth's atmosphere. They occur frequently in the northern latitudes but sometimes, during powerful solar storms, reach Nova Scotia.

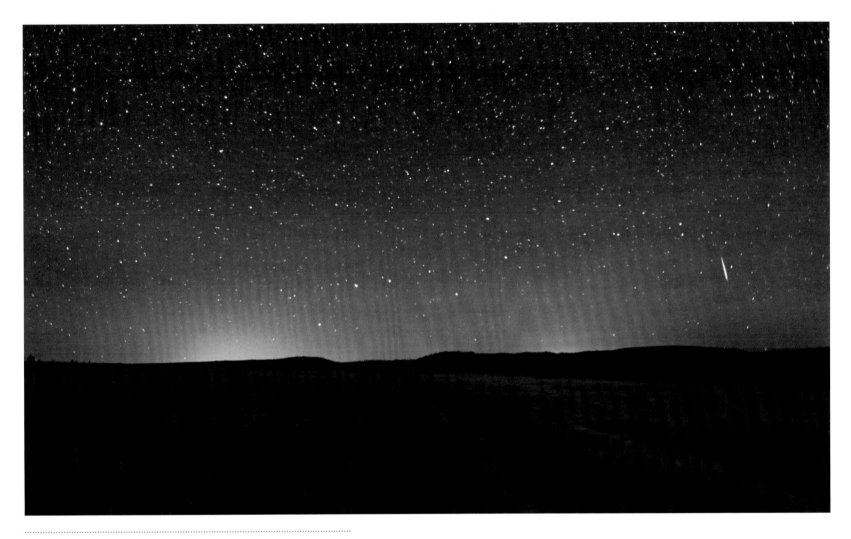

A single meteorite streaks over the blueberry fields on the plateau of the Cobequid Mountains in Cumberland County.

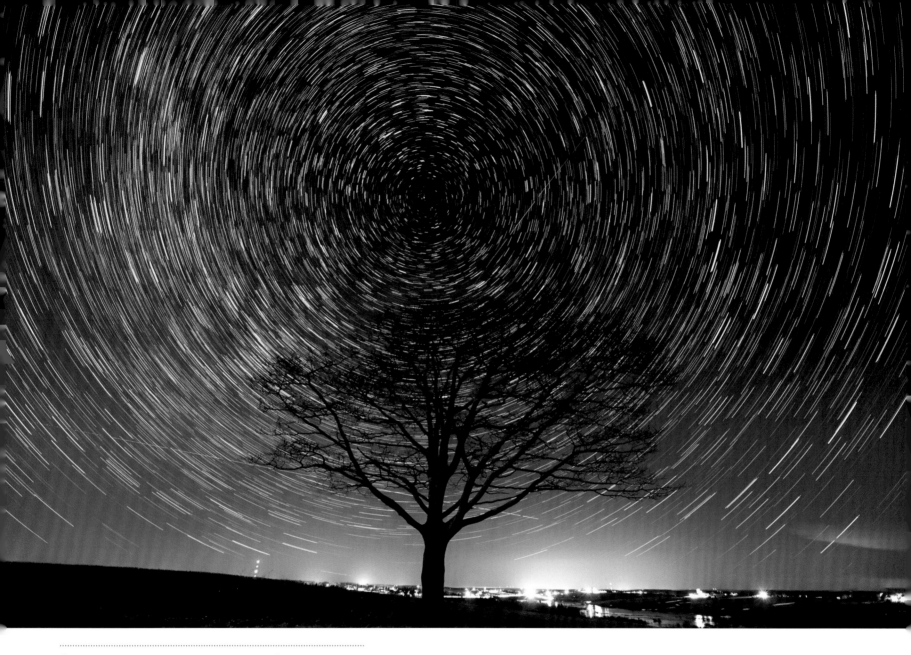

Stars appear to spin around the North Star in this time-lapse shot taken in Milford. As the earth rotates, the stars, as point light source on the film, appear to move.

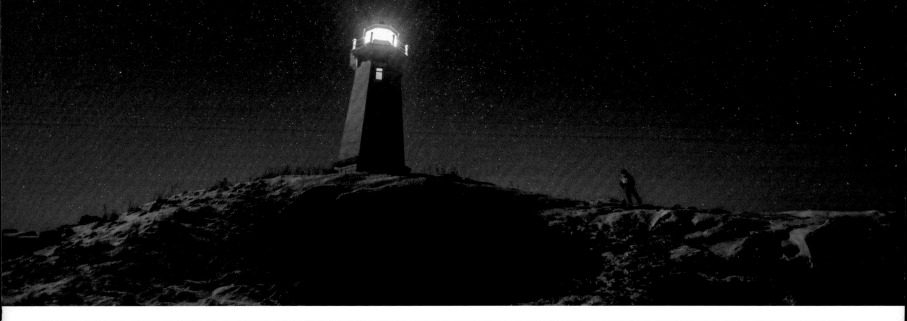

Above: A lone figure gives perspective to the lighthouse and night sky at Louisbourg on Cape Breton Island. The first lighthouse in Canada was built on this spot in 1734 to serve the port where the French fortress of Louisbourg was located. This is the fourth version of the Louisbourg lighthouse which had lightkeepers until the 1990s.

Next spread: We have all kinds of technology these days to tell us when the skies are going to light up with the northern lights or meteor showers. On this day, I headed out to Peggys Cove lighthouse to catch the Geminids (named after the astrological sign in the sky the showers will come from) in December. On this night, I arrived when the peak showers were expected and it was windy along the coast. You need to have a very still camera and the wind will blow the tripod around so I jumped into a crevice in the rocks to get out of it. I set the camera up and pressed the shutter for a test shot as I started looking for a good angle. Above me the meteor zipped through the sky behind the lighthouse. I spent another few hours there but nothing came close to this test frame.

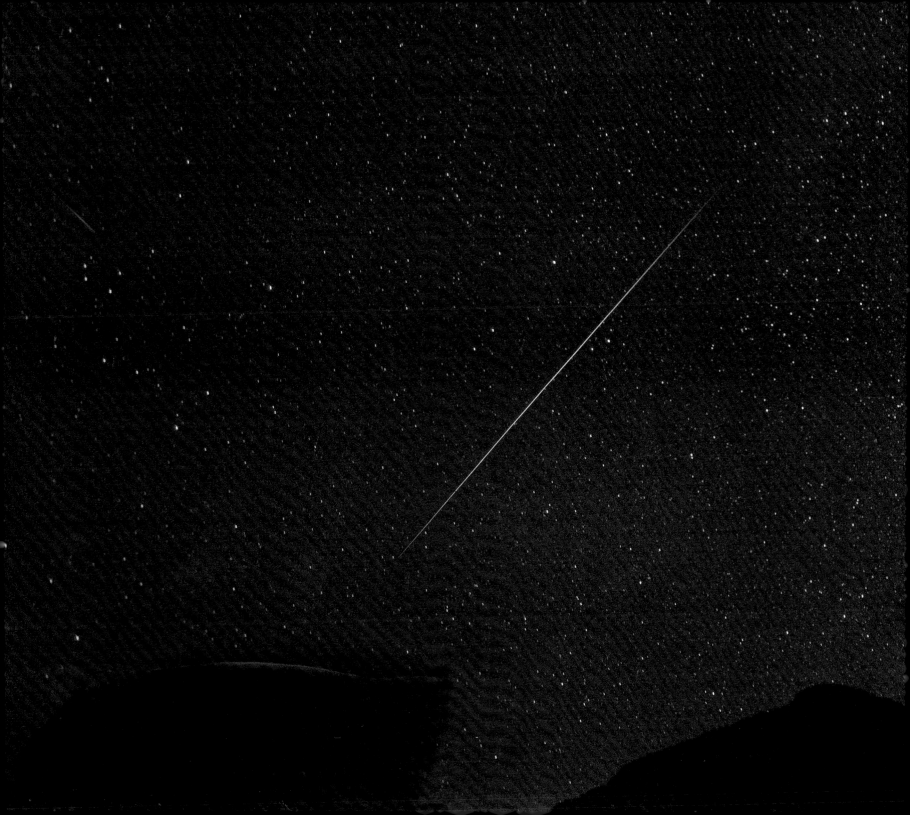

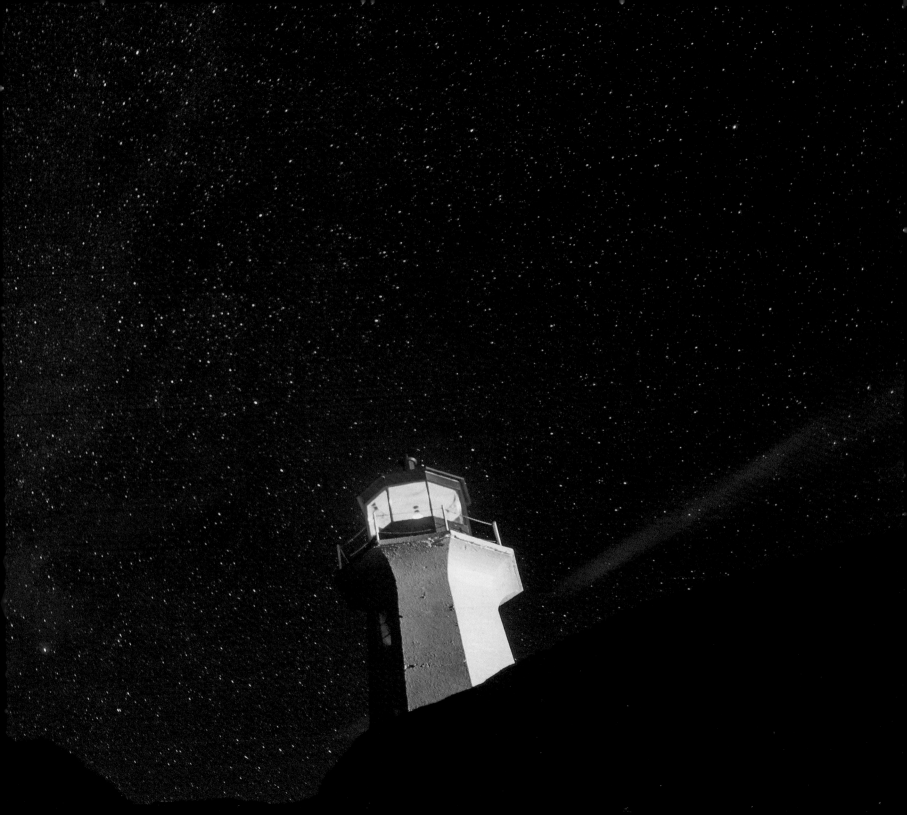

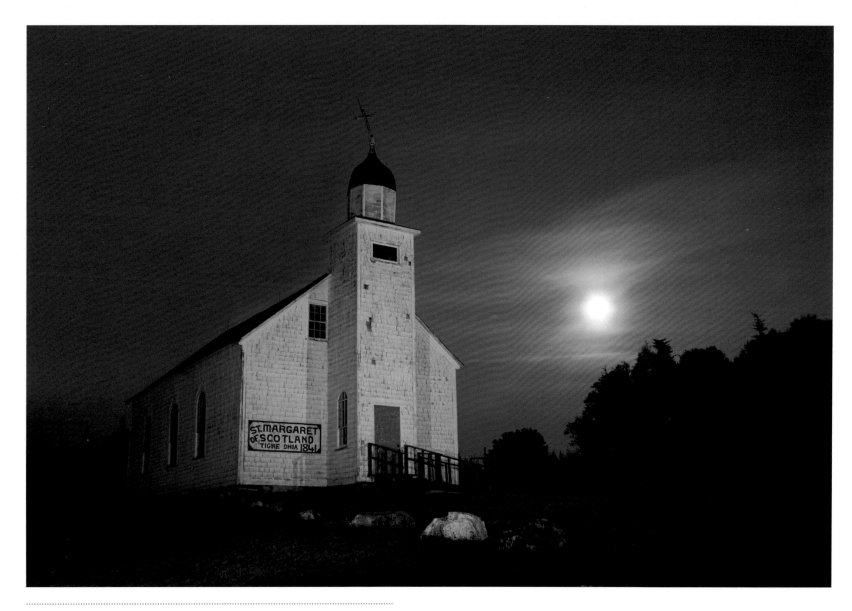

The moon sets behind St. Margaret of Scotland Church on the River Denys Mountain in Cape Breton. The church is all that is left of a once-thriving community in the highlands of Cape Breton.

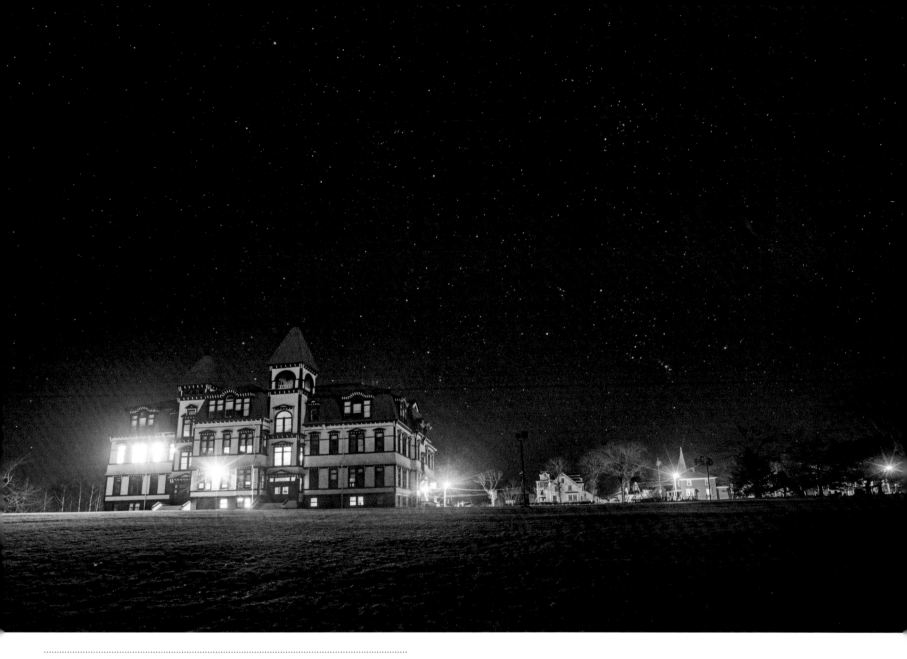

The Lunenburg Academy, built in 1895, stands like a beacon on Gallows Hill in Lunenburg. Students roamed the school's halls until 2011, when the new Bluenose Academy opened. A municipal, provincial, and federal heritage site, the building has been repurposed and used by various performing-arts organizations.

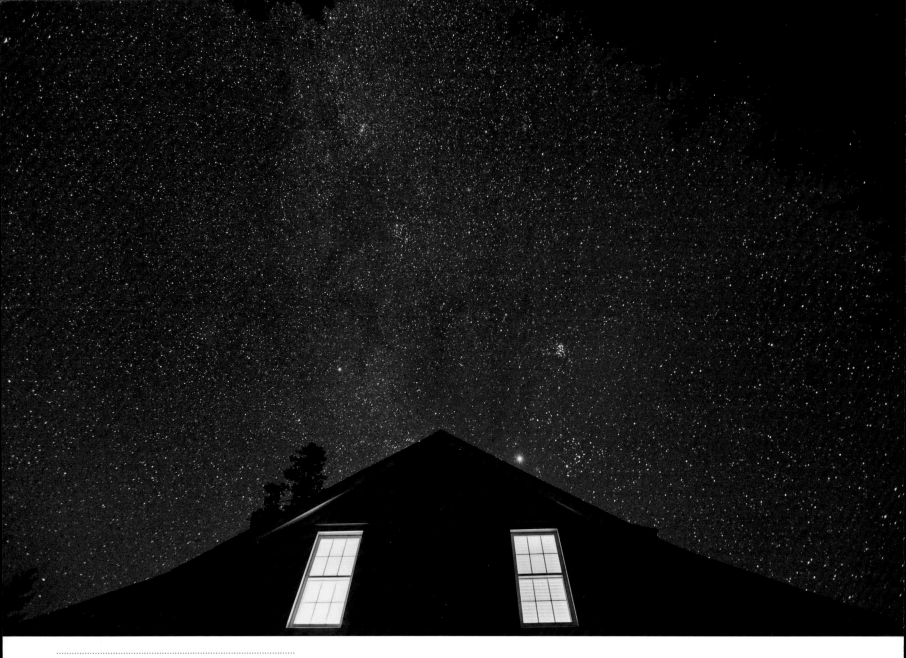

The Milky Way above a house in Parrsboro.

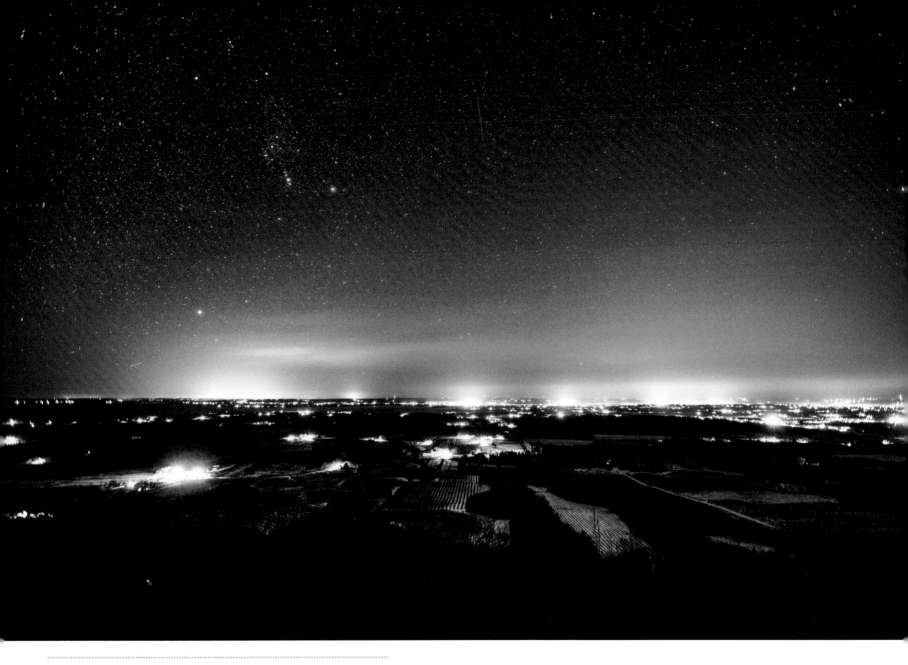

The constellation of Orion is clearly visible in this image taken at Blomidon Lookoff Provincial Park in Arlington, Kings County. On a clear day, you can see five counties from the near 600-foot perch.

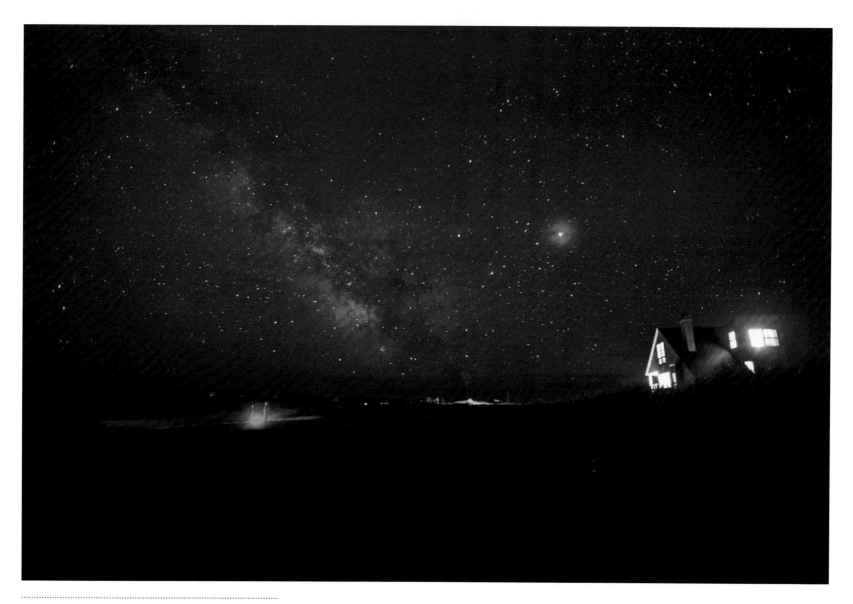

Friends enjoy a campfire on Kingsburg Beach while light spills from the house behind the dunes. The Milky Way rolls above them.

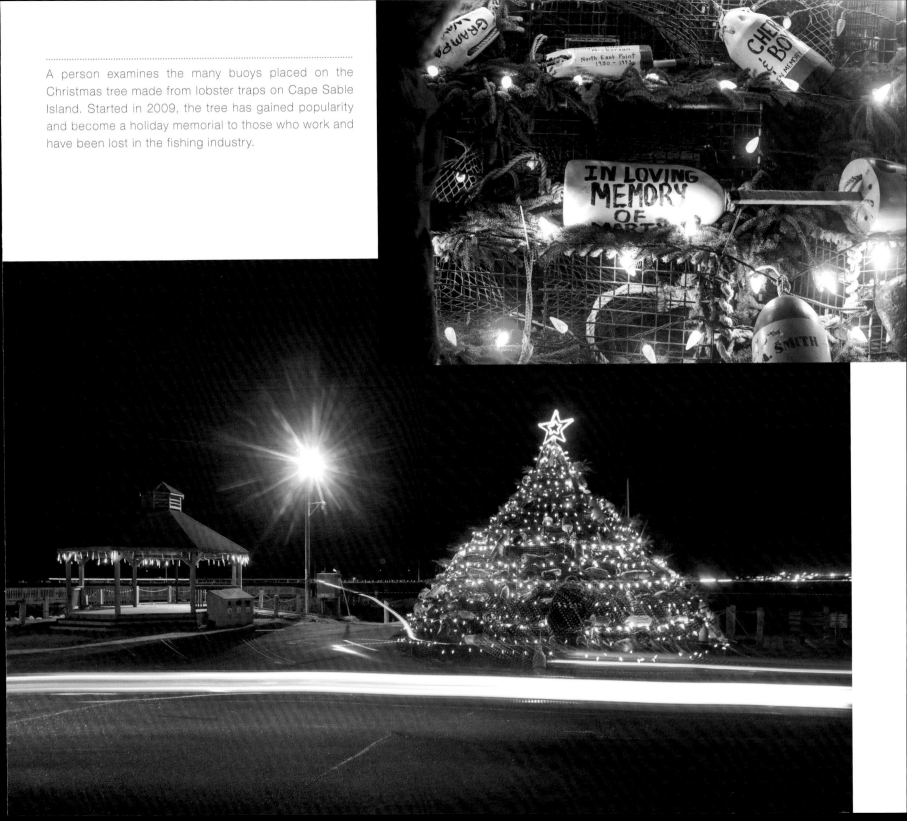

A person examines the many buoys placed on the Christmas tree made from lobster traps on Cape Sable Island. Started in 2009, the tree has gained popularity and become a holiday memorial to those who work and have been lost in the fishing industry.

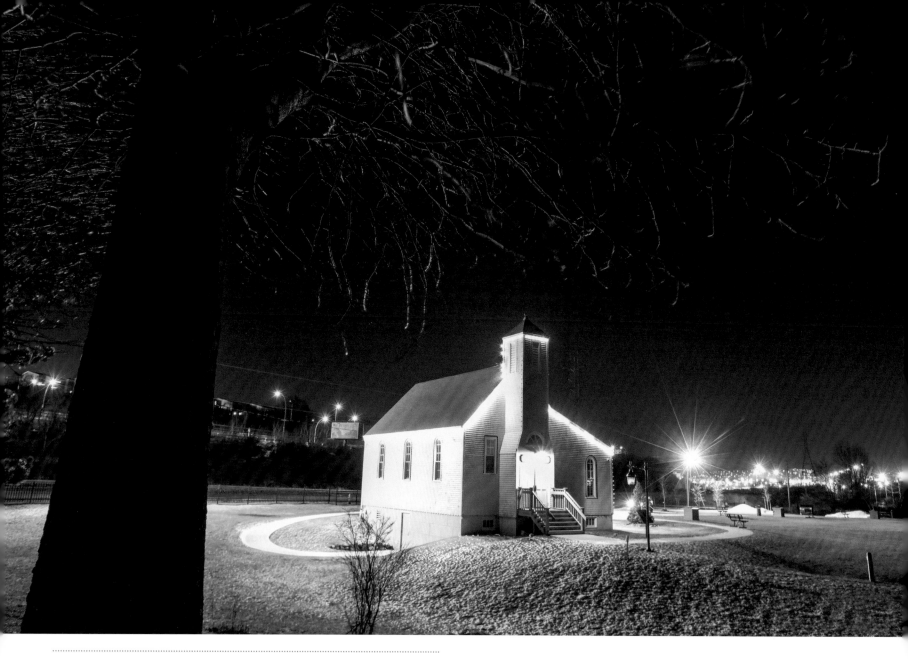

The Africville Church, reconstructed in 2011, sits on land that was once the community of Africville. Designated a national historic site in 1996, the community was demolished in the 1960s to make way for highways and a bridge. The museum, located in the church, celebrates the rich African Nova Scotian culture that dates back hundreds of years.

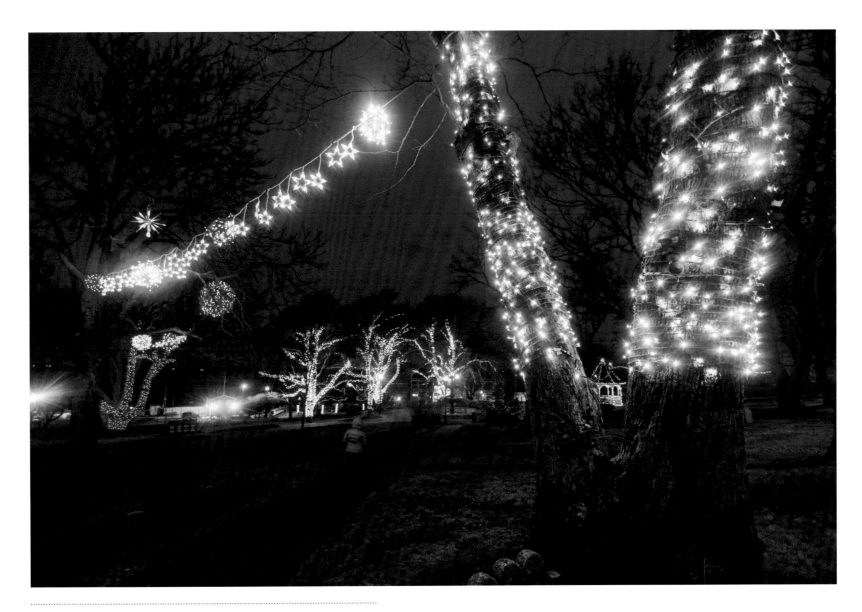

The trees in Yarmouth's Frost Park are lit up with thousands of LED lights for the holiday season. It has been said that some of the inspiration for "It's beginning to look a lot like Christmas" came from this very place. The story goes that the writer of the song spent a few days in the town, and in the song, refers to the park and the hotel across the street.

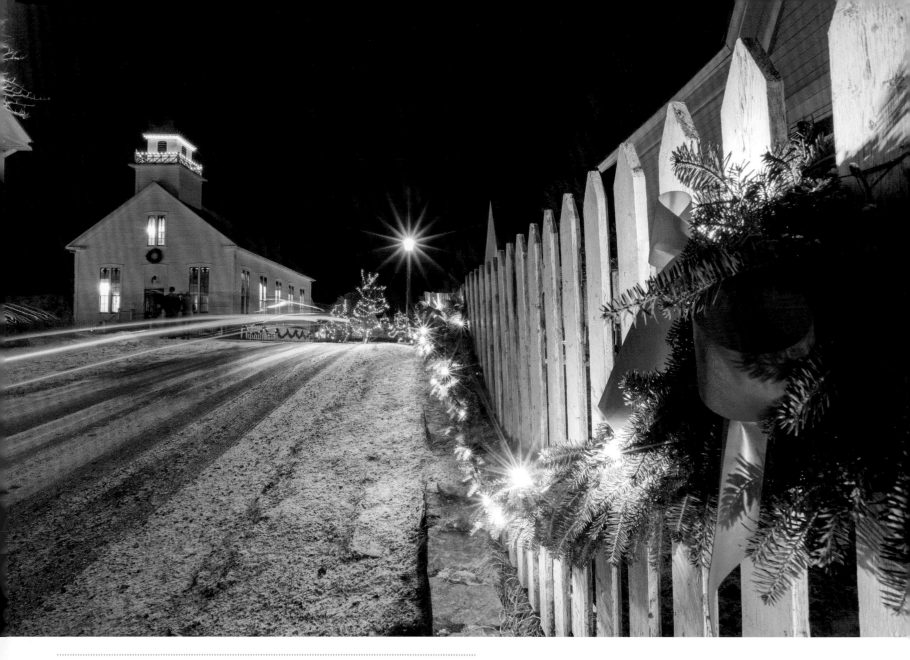

A car filled with sightseers travels along a street in Sherbrooke, Nova Scotia.

Over twenty thousand lights are hung around Sherbrooke Village in Sherbrooke for the Old-Fashioned Christmas celebration. The village, on the eastern shore of the province, transports visitors back to life in the 1800s.

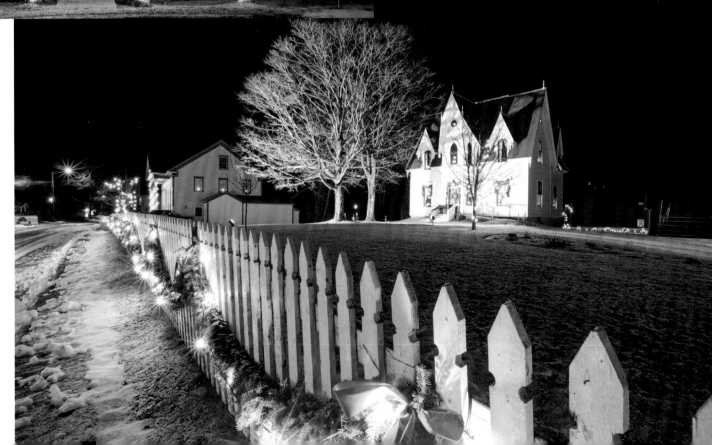

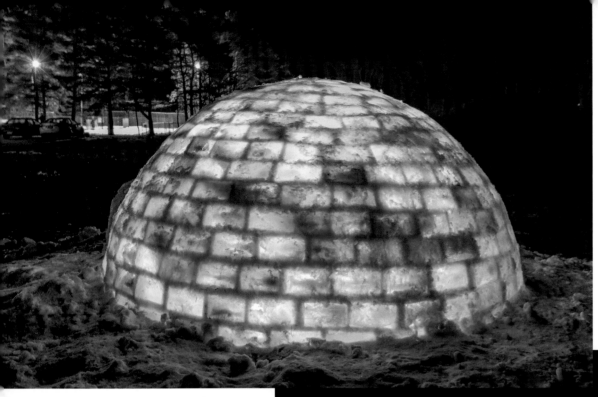

An igloo, made of water frozen in milk cartons with food colouring and built as part of the community of Hantsport's winter carnival celebrations, shines from the lights inside it. Behind it, friends partake in an outdoor game of hockey on a winter's night.

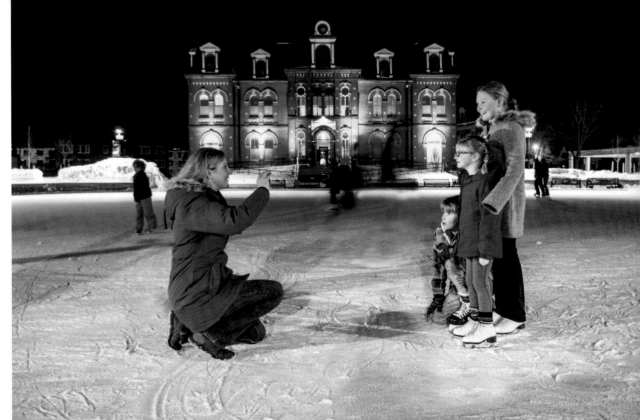

Kate Currie kneels as she takes a picture of her children, Madeleine, Isaac, and Charleigh, who are ready to skate at the Civic Square outdoor skating rink in Truro. The free skating area in the downtown has become a gathering place for families to socialize and enjoy the outdoors.

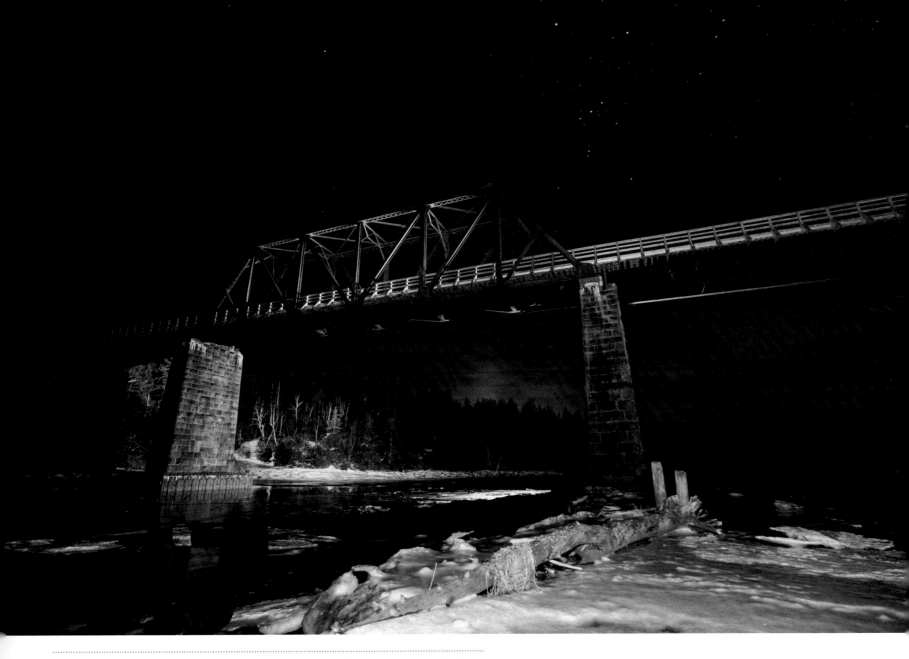

The Wallace River Swing Bridge shines against the night sky over the Wallace River. Built in the late 1800s, the bridge had a swing feature to allow ships to go upstream to the sandstone quarries. The abandoned rail line is now part of the Trans-Canada Trail.

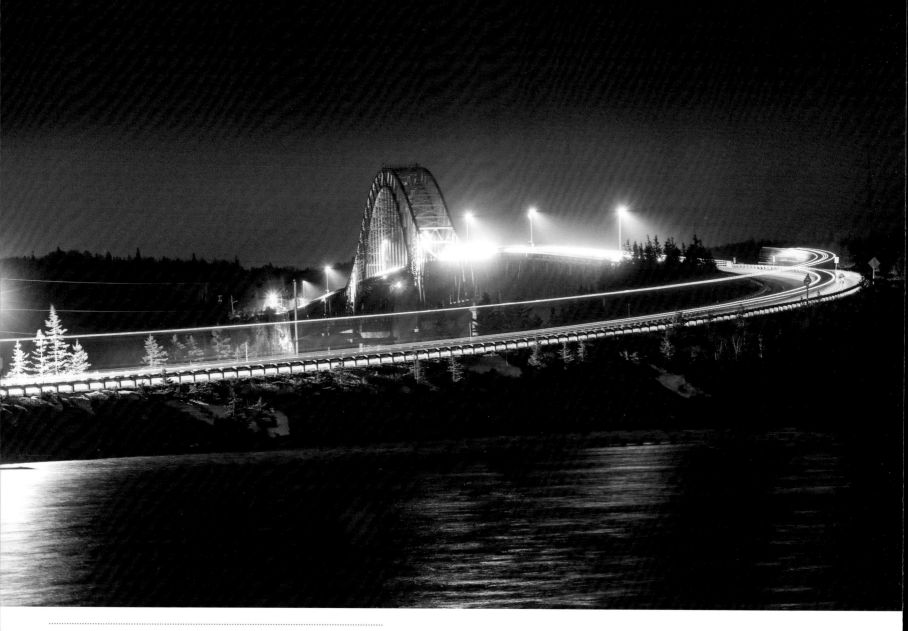

Transport trucks leave streaks of light as they cross the Seal Island Bridge on Cape Breton Island. The bridge, opened in 1961, crosses over the Great Bras d'Or Channel.

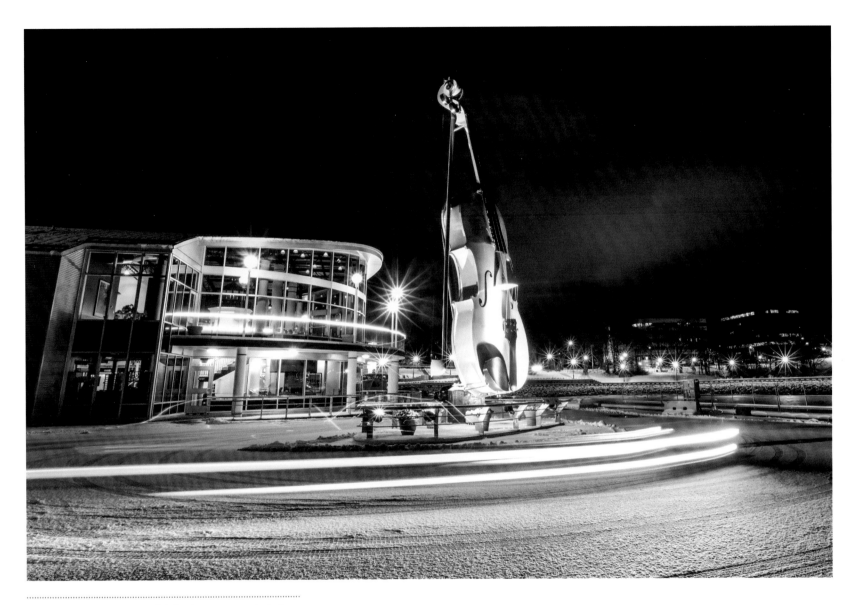

Since 2005, the giant fiddle has greeted visitors to the Sydney waterfront on Cape Breton Island. The seventeen-metre fiddle, created by artist Cyril Hearn, pays homage to the island's Celtic heritage.

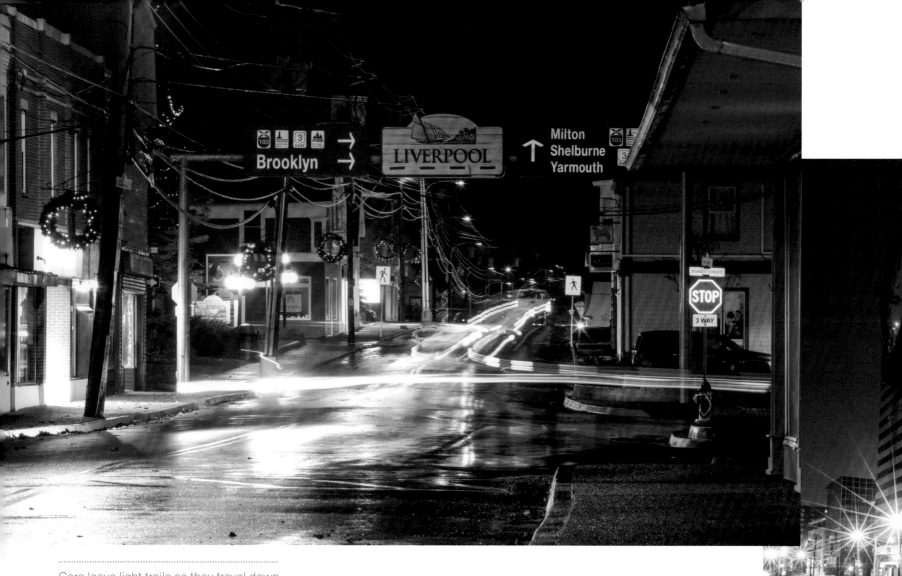

Cars leave light trails as they travel down
the streets of Liverpool on the province's
south shore.

The corner of Portland and Alderney Streets
in Dartmouth.

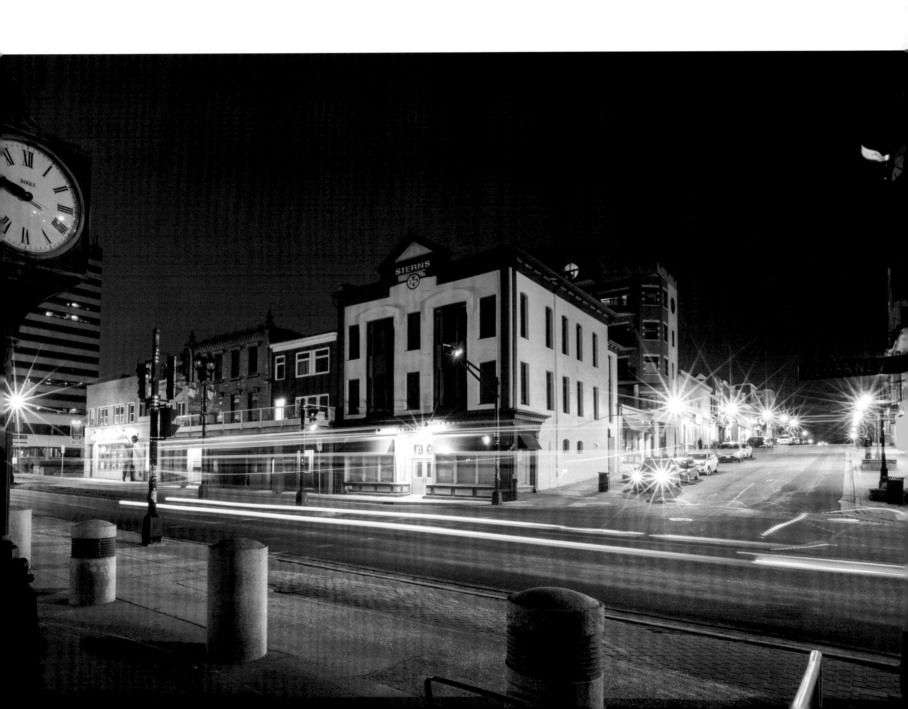

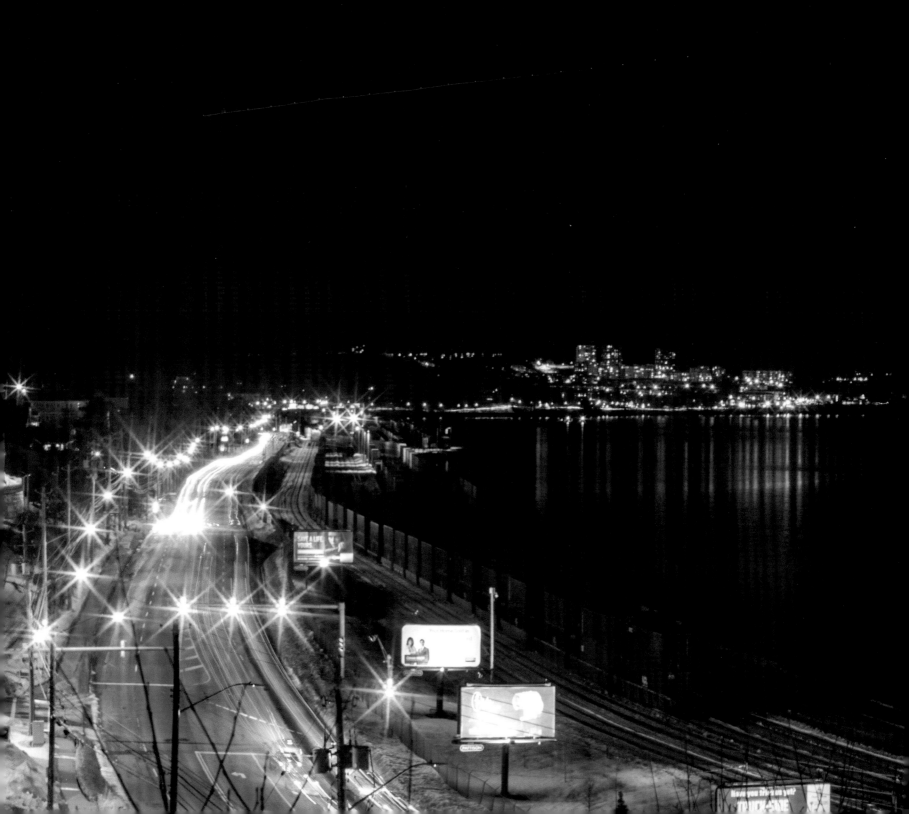

Opposite: Planes, trains, and automobiles. Vehicles and trains move along the shores of the Bedford Basin in Rockingham. The main rail line into the port city's two container piers and one of the major vehicle arteries into Halifax, the roads see thousands of commuters every day.

Below: Cars make their way along the Fairview overpass in Halifax.

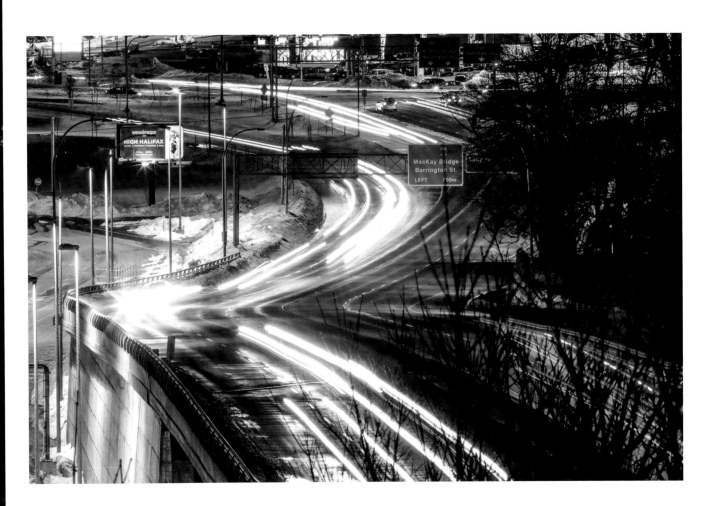

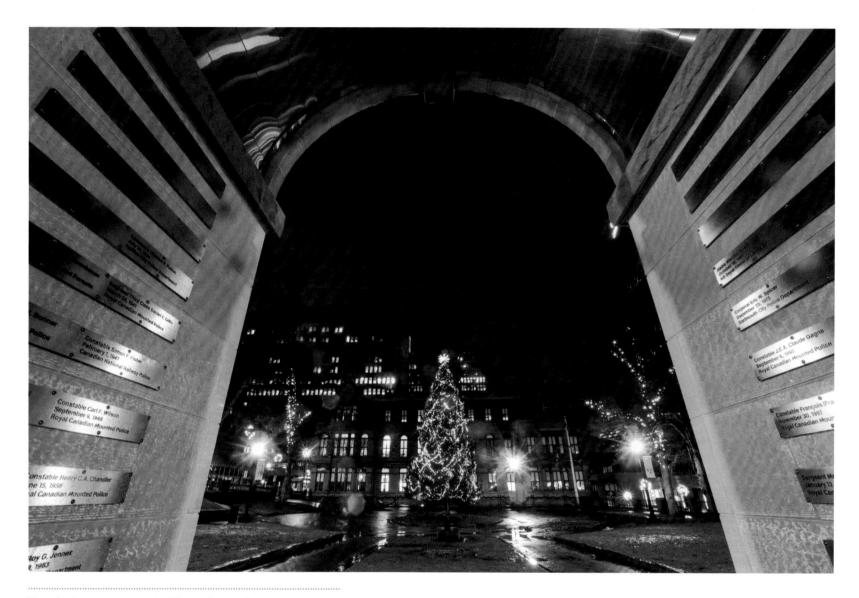

The Christmas tree in Halifax's Grand Parade is framed
by the monument to slain peace officers, which was
unveiled in 2010.

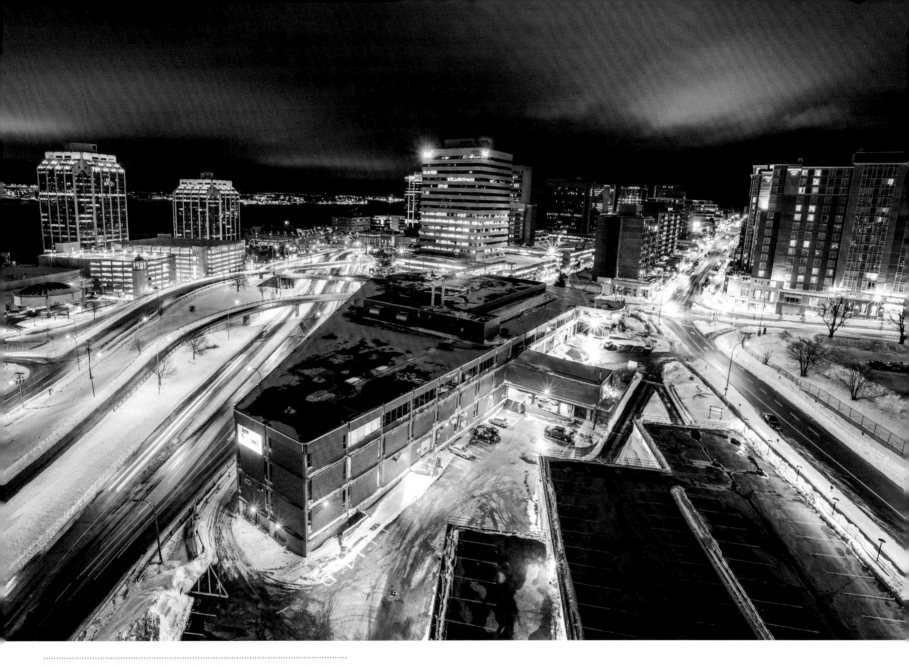

Cars make their way in and out of downtown Halifax's Barrington and Brunswick Streets after roads have been cleared following a snowstorm.

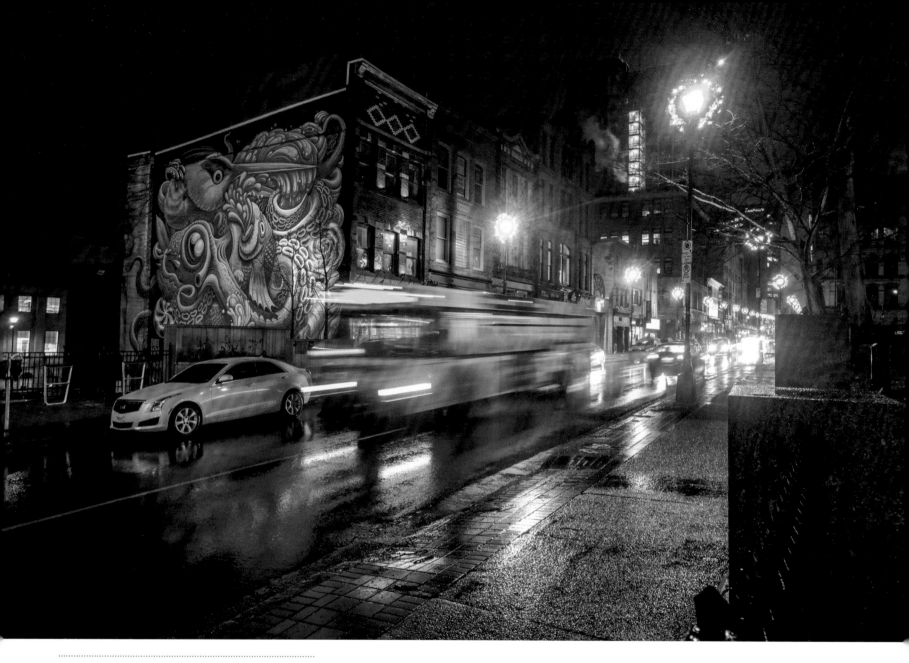

A transit bus blurs as it travels along Barrington
Street in Halifax.

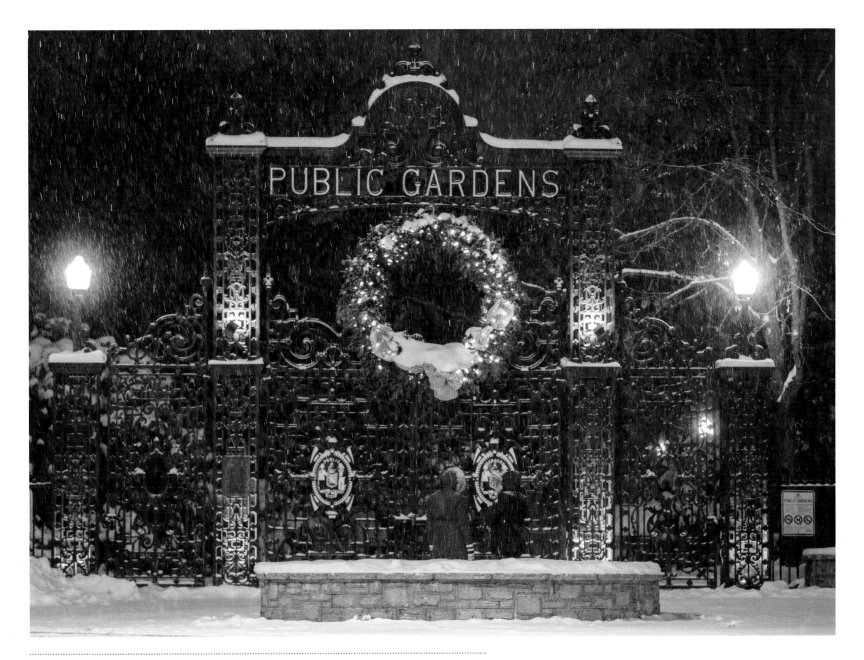

Two visitors examine the gates at Halifax's Public Gardens. The Victorian gardens have been a spot where Haligonians can enjoy the flora and fauna. Closed in the winter, its massive gates, complete with a wreath, maintain that Victorian feel.

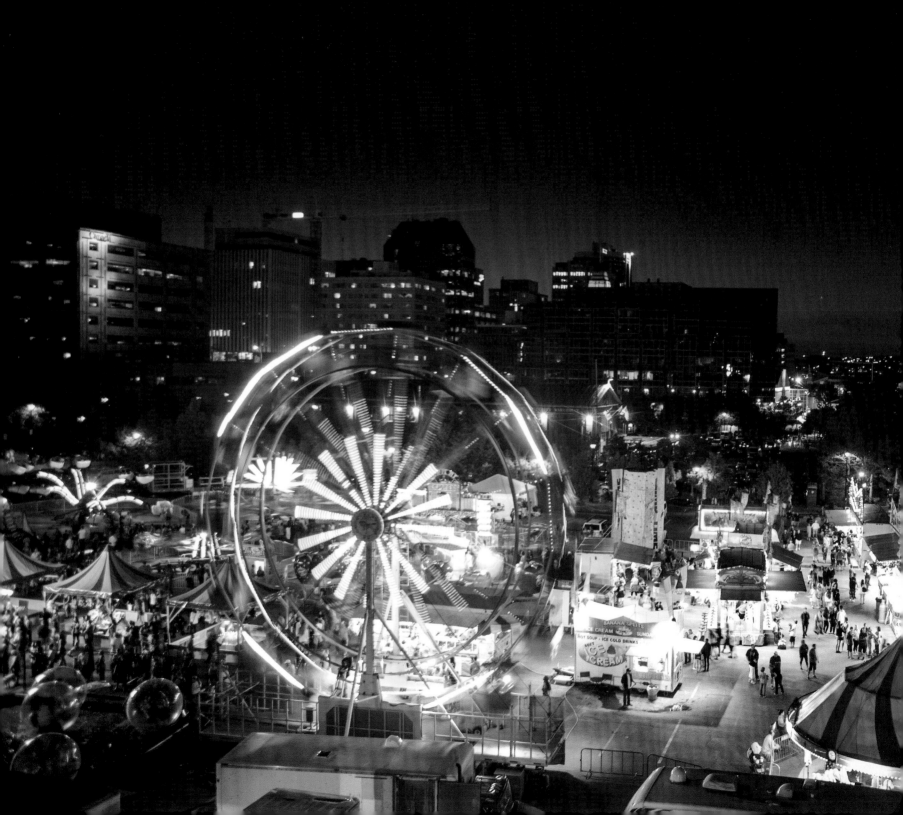

The sights and smells bring back memories of childhood when the carnival rolls into town. As they have for decades, the rides and games draw people to the fun on summer evenings like this one in Halifax.

81

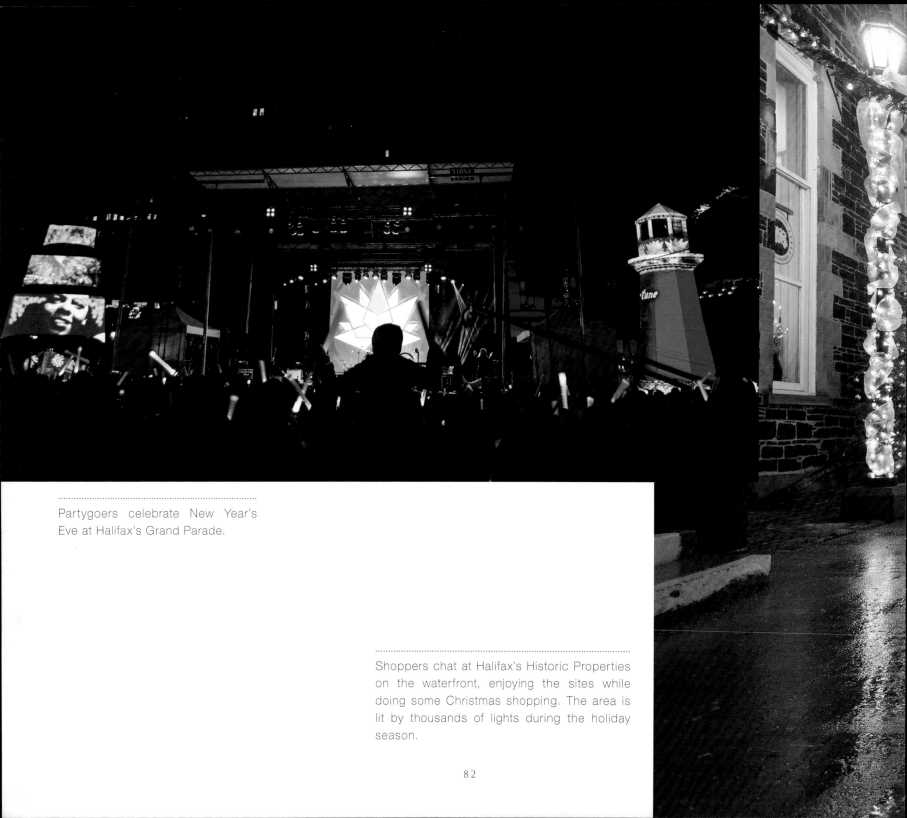

Partygoers celebrate New Year's
Eve at Halifax's Grand Parade.

Shoppers chat at Halifax's Historic Properties
on the waterfront, enjoying the sites while
doing some Christmas shopping. The area is
lit by thousands of lights during the holiday
season.

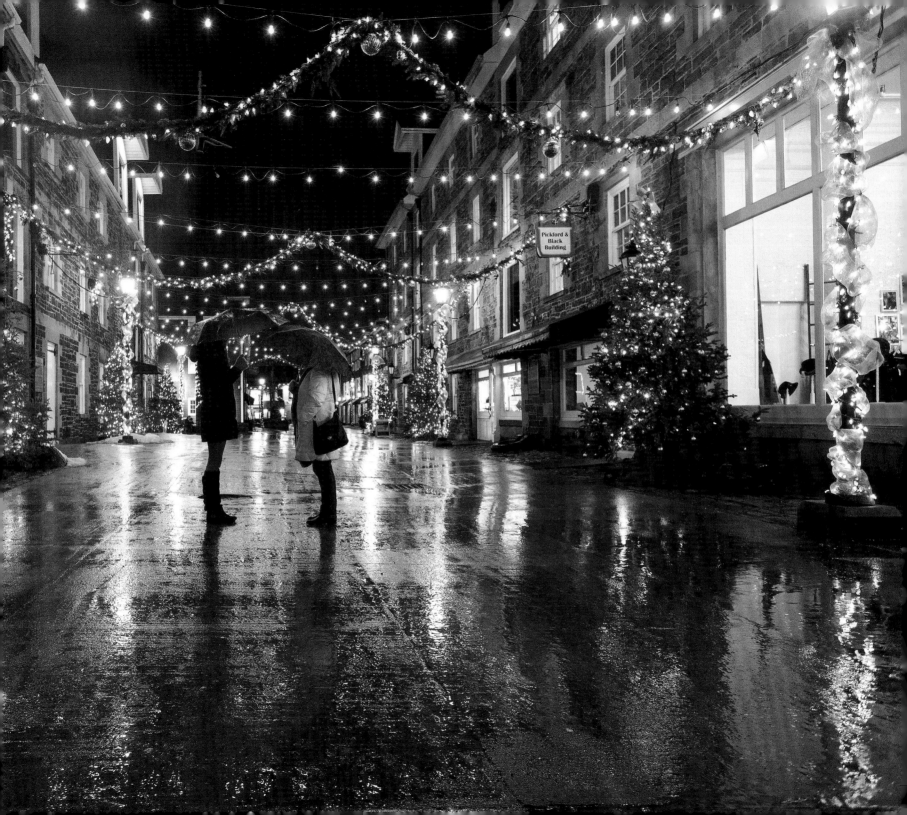

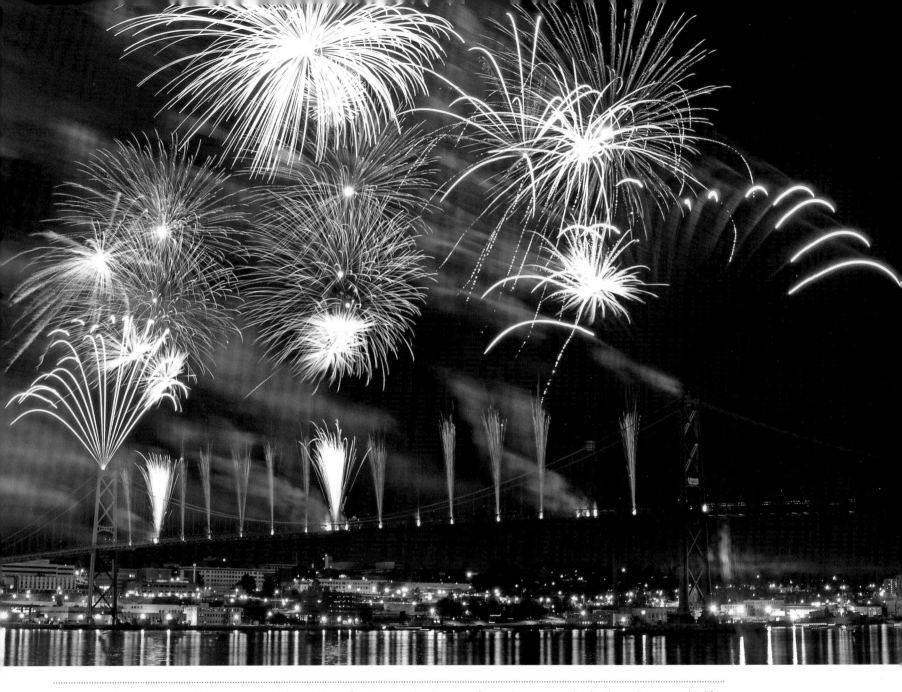

The Angus L. Macdonald Bridge, named after a Nova Scotia premier, is one of two that spans the harbour between Halifax and Dartmouth. Opened in 1955, the 1.3-kilometer-long suspension bridge is being refurbished in a project known as the "The Big Lift." The bridge sometimes serves as the platform for fireworks during the city's Natal Day celebration.

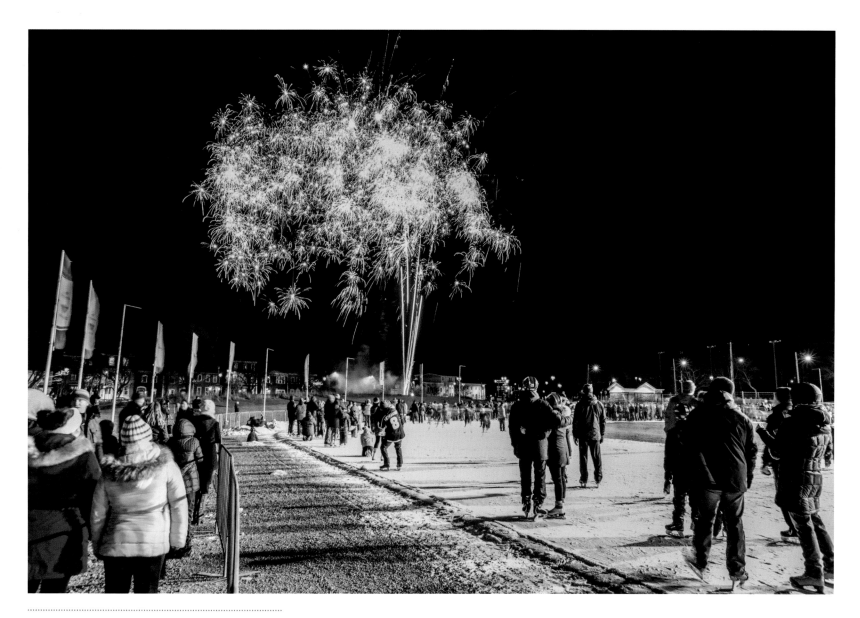

Skaters on the Emera Oval watch the New Year's fireworks explode over the Halifax Commons. Originally built for the 2011 Canada Games, the "Oval" has become a winter tradition in the city.

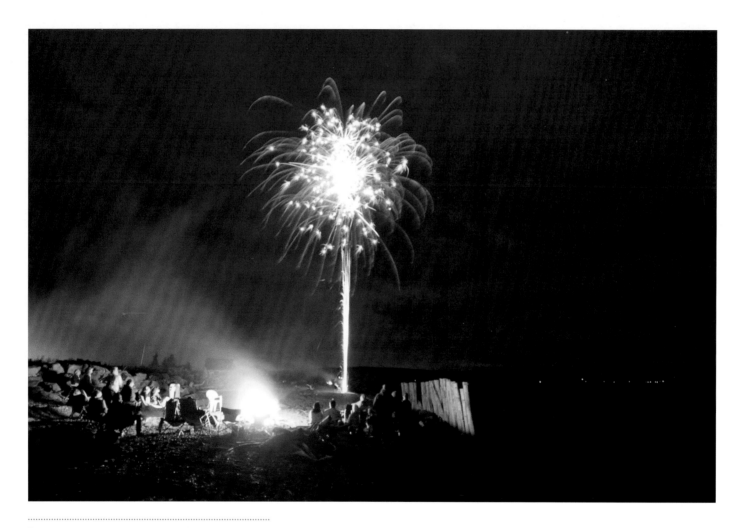

Beachgoers enjoy a bonfire, fireworks, and camaraderie during Advocate Days in Advocate Harbour on the Bay of Fundy.

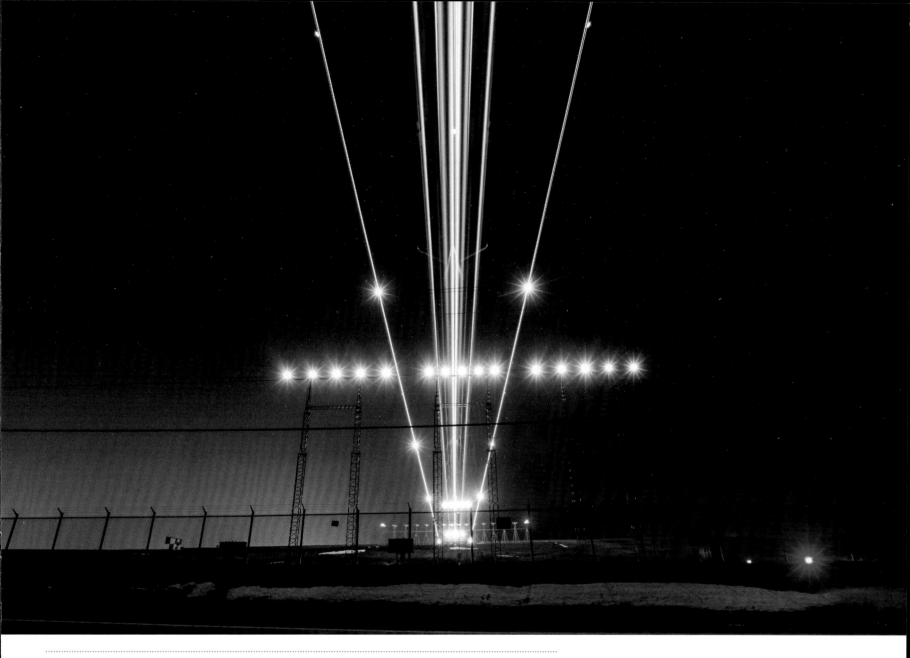

Lights from a landing passenger plane leave a trail as it lands at Halifax Stanfield International Airport. Planes have a green light on the right wingtip and a red on the left, thus the different colours. The white blink is a strobe that flashes on the plane to improve its visibility. The airport, built in the 1960s, is Halifax's third. The first was along Chebucto Road on the peninsula and closed in 1942; the second was at CFB Shearwater.

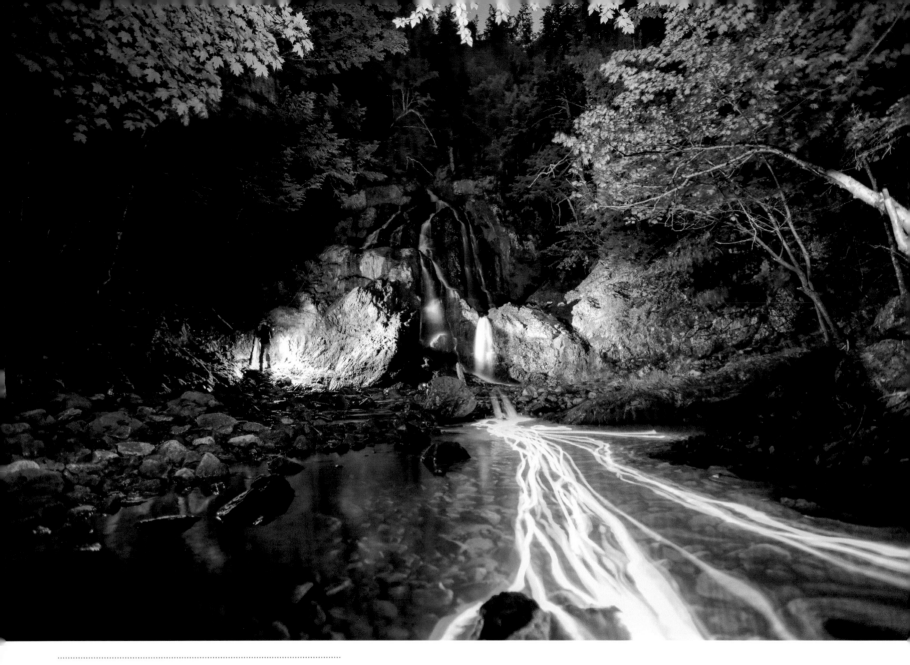

A waterfall in the Wentworth Valley is illuminated by the lights of glow sticks as they travel through the water.

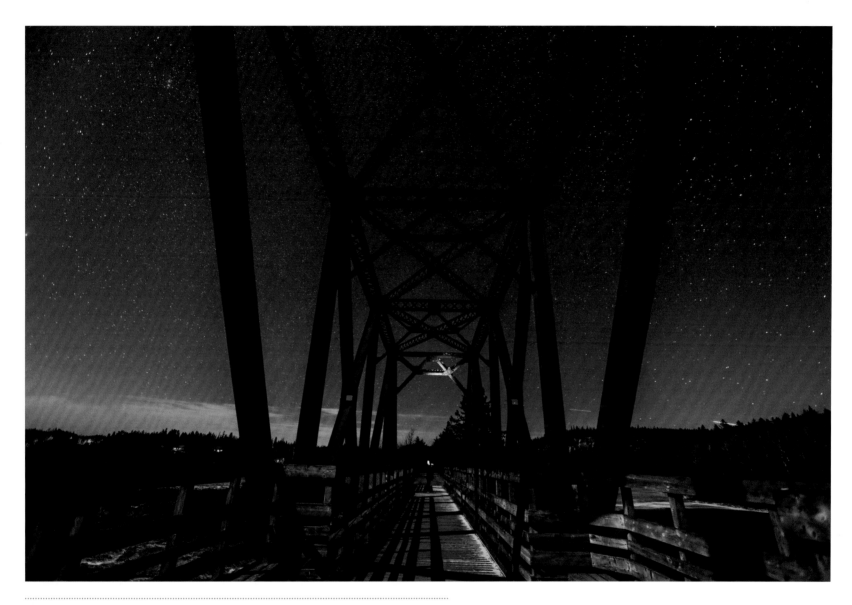

A pedestrian lights up the abandoned railway bridge over the Musquodoboit River at Musquodoboit Harbour. Railways ran along all parts of the province from the late 1800s until they became used less for passengers and freight in the latter part of the 1900s. Many of the abandoned lines are maintained by community groups and some have become part of the Trans-Canada Trail.

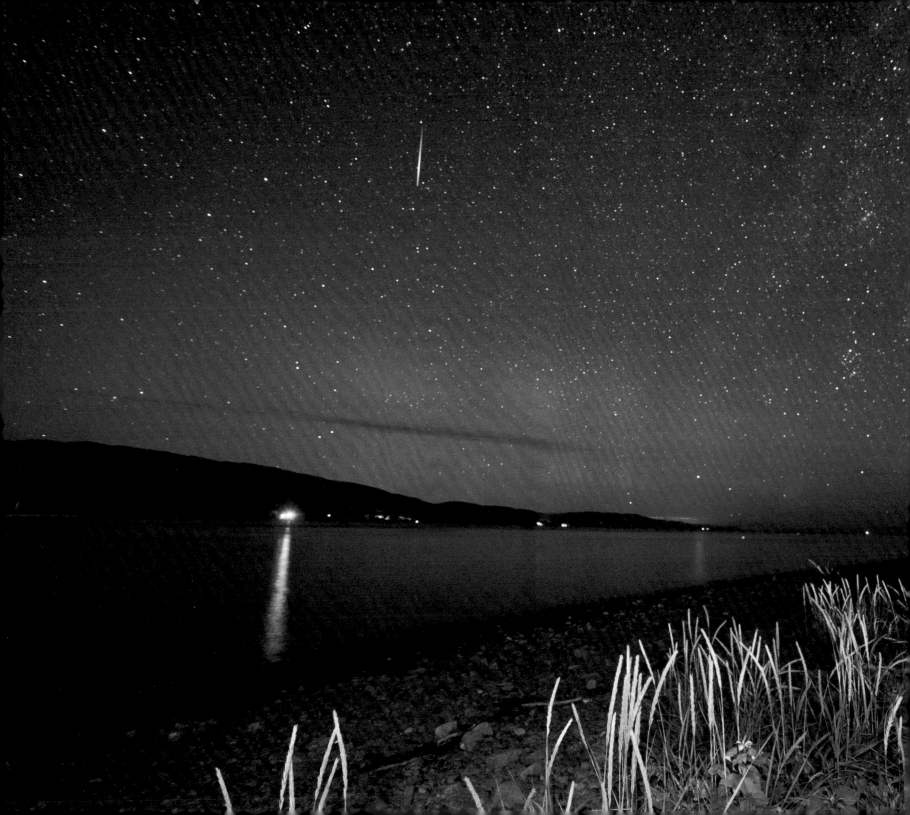

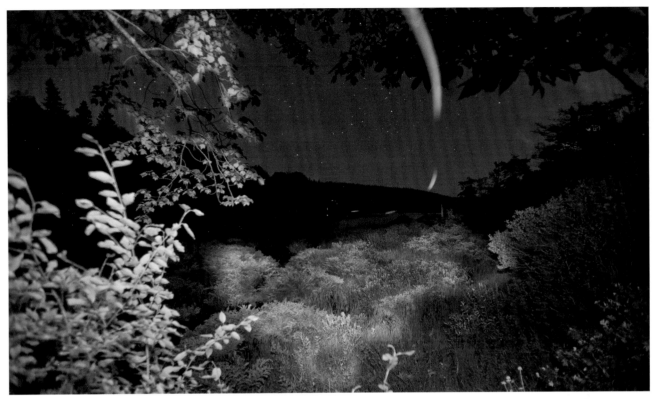

Featured photographer: Adam Hill

Above: Aurora storms can bring amazing displays of aurora all over the northern Canadian sky, but during the most intense storms the aurora can be viewed as far south as Nova Scotia! I've chased the aurora in northern Canada for just under a decade but I've always wanted to photograph from a southern point of view so I could see the aurora from the side.

I travelled to Englishtown to get a clear view of the northern sky. I tried the view from the St. Anne's lookoff but I moved to new location at sea level hoping I'd be able to expose some reflection of the aurora in the water. Unfortunately, the aurora was starting to fade away at this point but luckily I was treated to a photo with a shooting star!

Opposite: One night while photographing the Milky Way, I walked to a small cove on the edge of my family's property in Scotch Lake. While I was there I took out my headlamp and began to light paint the bushes and trees that surrounded the cove; during this time two fireflies started to light up. I was hoping they would begin to attract the attention of other fireflies but while they were flying one flew just inches above my head and down into the cove, creating a beautiful trail of light showing where it flew. I knew I had great photo on my hands if the timing of the exposure worked out.

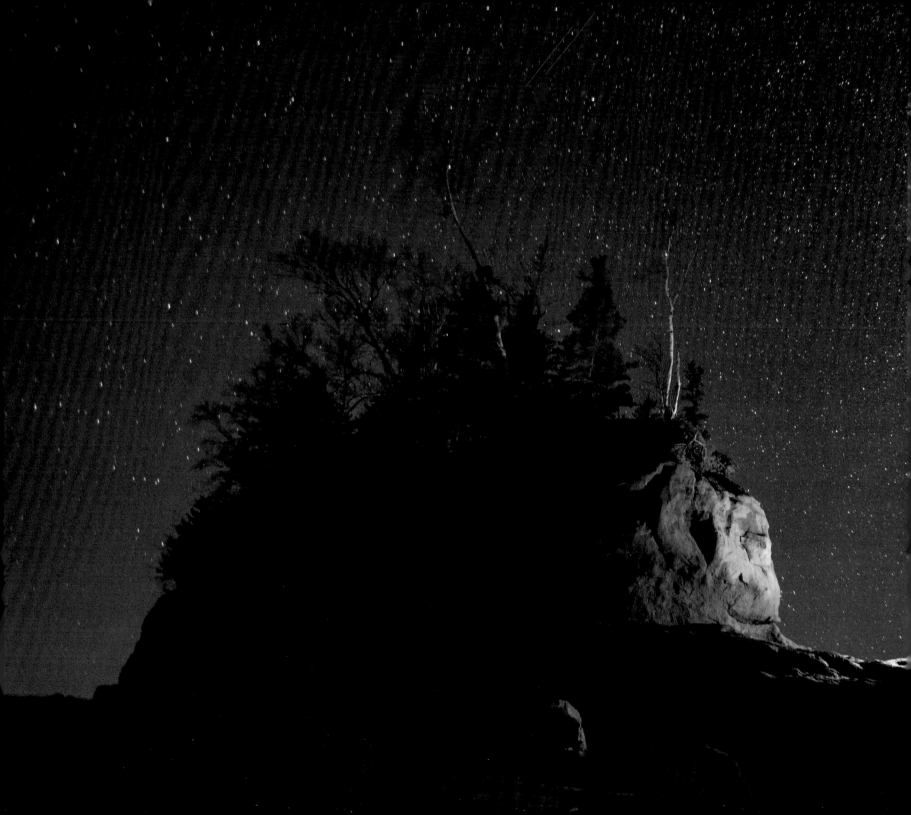

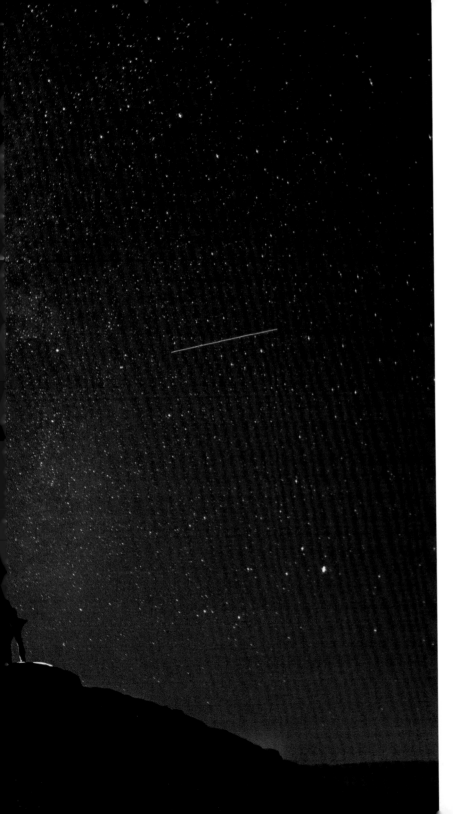

A hiker watches the night sky's Milky Way along the shores of the Minas Basin near Burntcoat Head. The Bay of Fundy is known for the world's highest tides, which were recorded at seventeen metres at Burntcoat Head.

A lone hiker shines a lamp near frozen waterfalls in Baxter's Harbour on the shores of the Bay of Fundy. The falls are formed from a freshwater brook, and when the tide comes in the salt water melts the icicles. Visitors need to be mindful of the tides and check before venturing away from safety.

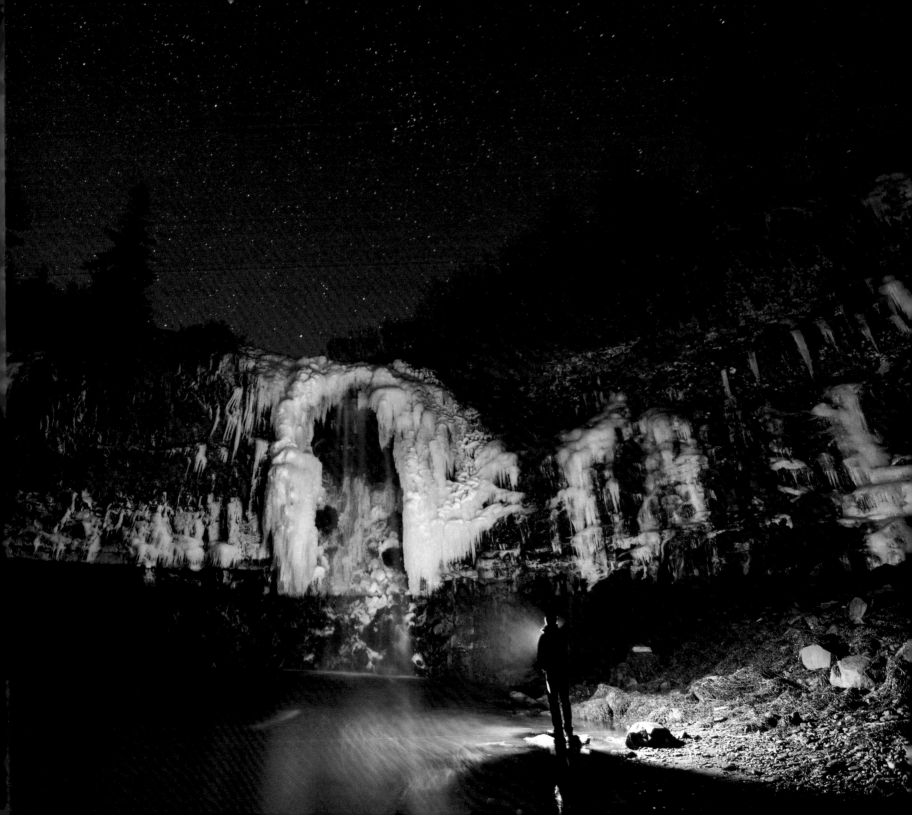

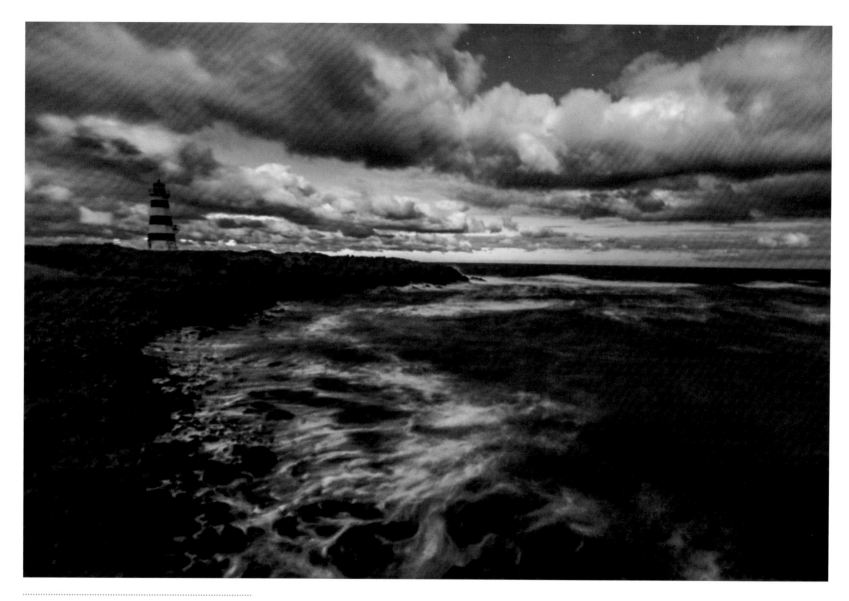

The waves and clouds move through the
night sky illuminated by a full moon at
West Light on Brier Island.

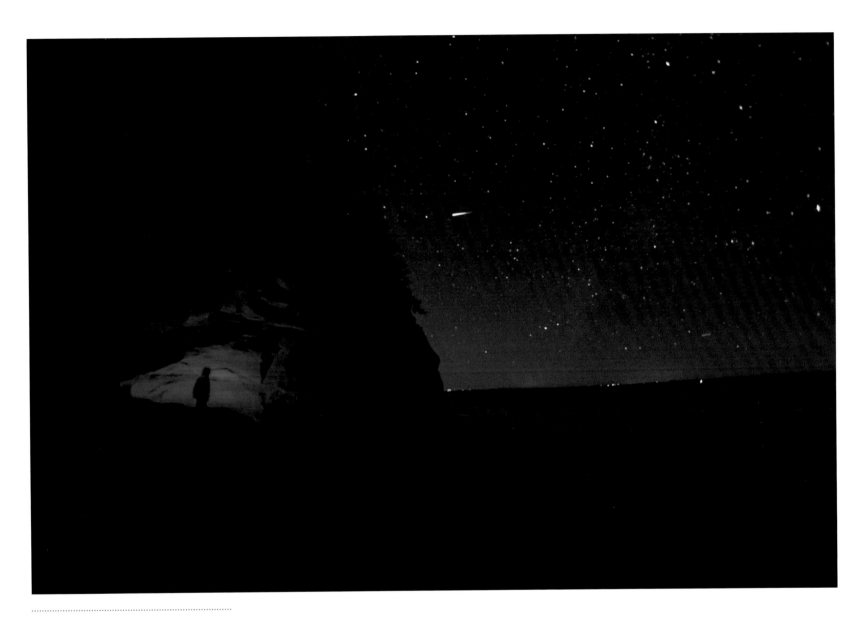

A lone hiker stands in the mouth of
an indentation at Burntcoat Head,
site of the world's highest tides
ever recorded, as a meteor streaks
through the night sky.

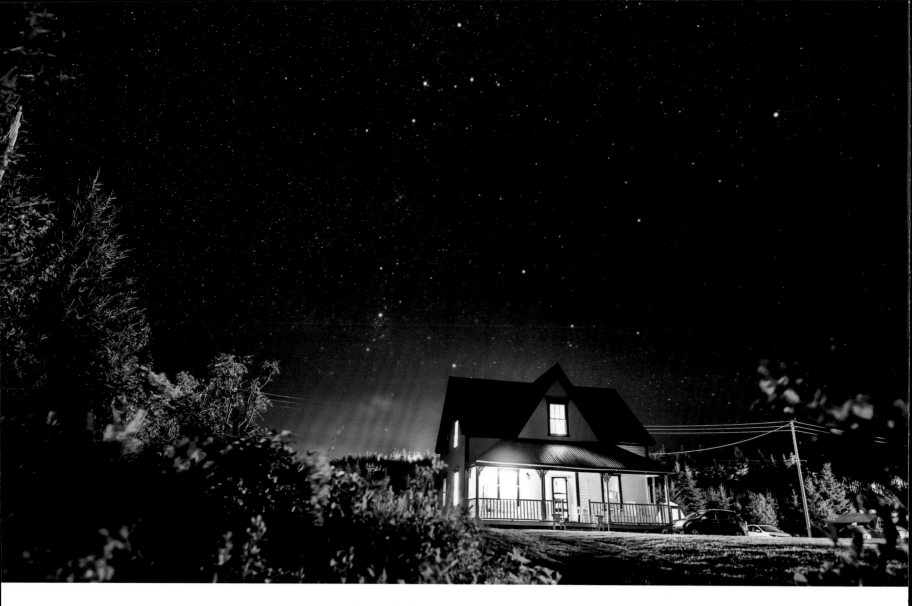

Featured photographer: Pam Collins

Liscomb. This photo was taken at our family summer property—a place I have been visiting each year since I was born. I still remember the sense of wonder I had as a child going outside to look at the stars with my cousins. This was before we had street lights and electricity. It left such an impression on me. Whenever I have the opportunity to take photos of the stars I get giddy about the night sky, excited to run around in the dark with expensive equipment and ill-fitting boots on slippery rocks near the ocean. The camera can see so much more than the naked eye, so astrophotography gives me a tiny glimpse of the billions of stars in our night skies, and the miraculous feeling that we are alive and thriving on our tiny speck in this wondrous galaxy. Fun fact: I once read that for every grain of sand on earth, there are about 10,000 stars in the universe. (*Wait but Why*, November 12, 2013).

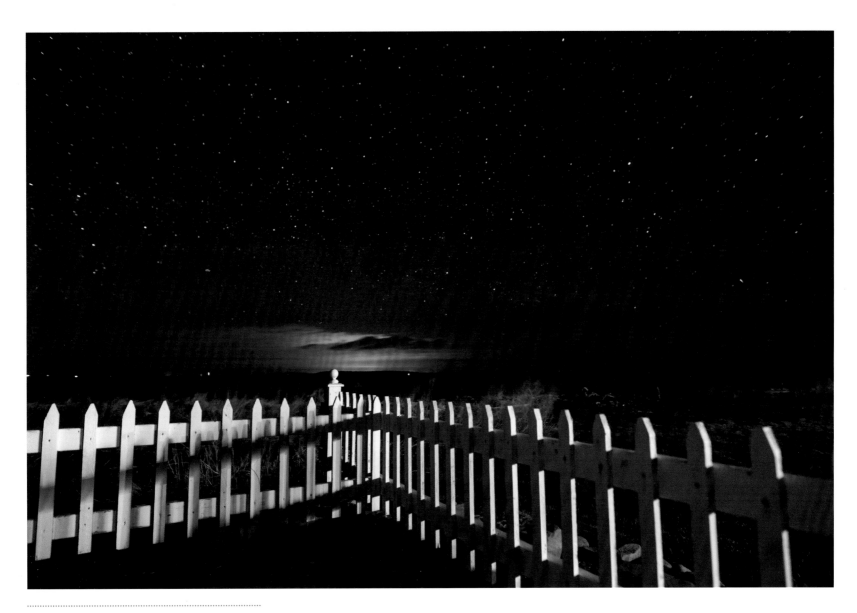

This shot was taken in April of 2017 in Malagash. The view of the night sky is northeast towards Prince Edward Island. The white picket fence denotes one type of home, but the stars another.

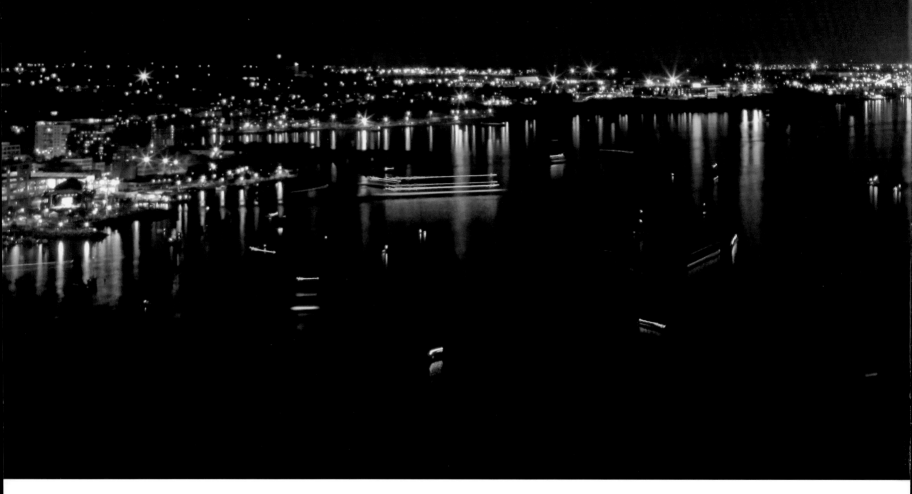

Featured photographer: Tim L'Esperance

Spectators in boats and on shore await fireworks over Halifax
Harbour. The lines on the water are caused by the boats' lights,
which seem to move during the camera's long exposure.

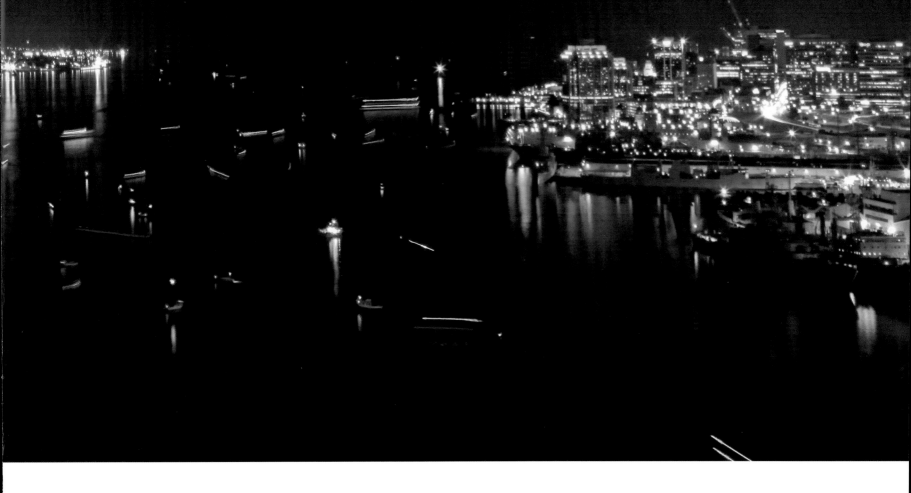

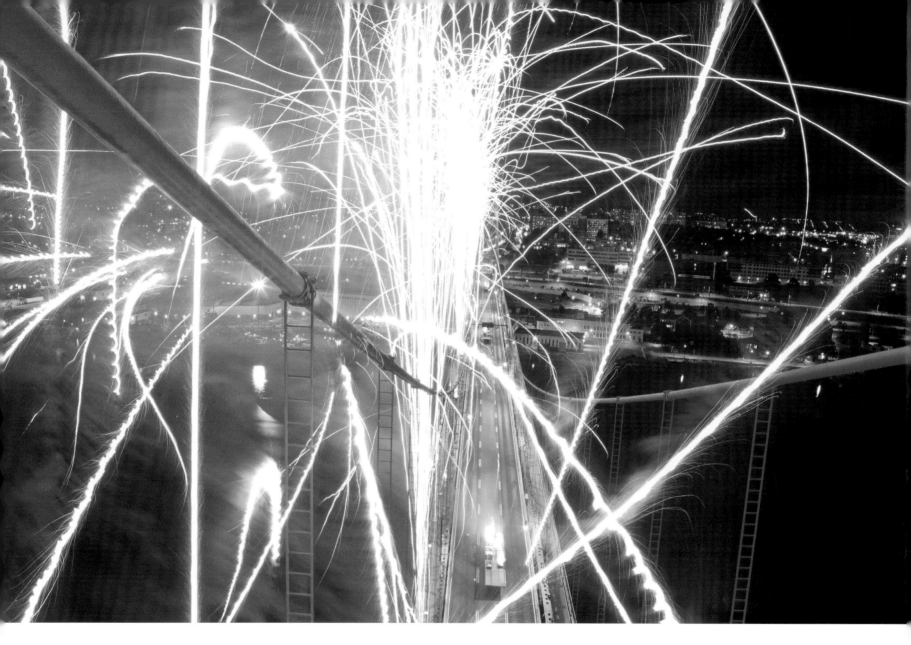

Featured photographer: Tim L'Esperance

Fireworks imagery from within the show perched atop the Macdonald Bridge: simply, an experience that I will never forget. The initial exhilaration of the vantage was quickly overtaken by much more excitement from the first explosion onwards: the overwhelming noise, the vibration of the entire bridge paired with the remarkable explosions of light, colour, and array that came together to create these images.

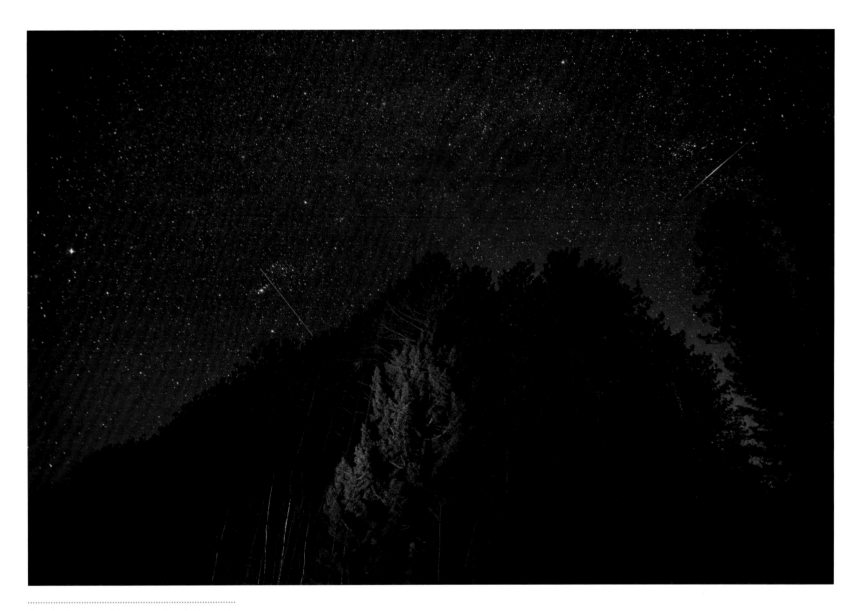

An airplane and meteor streak through
the night sky in the Chignecto Game
Sanctuary in Cumberland County.

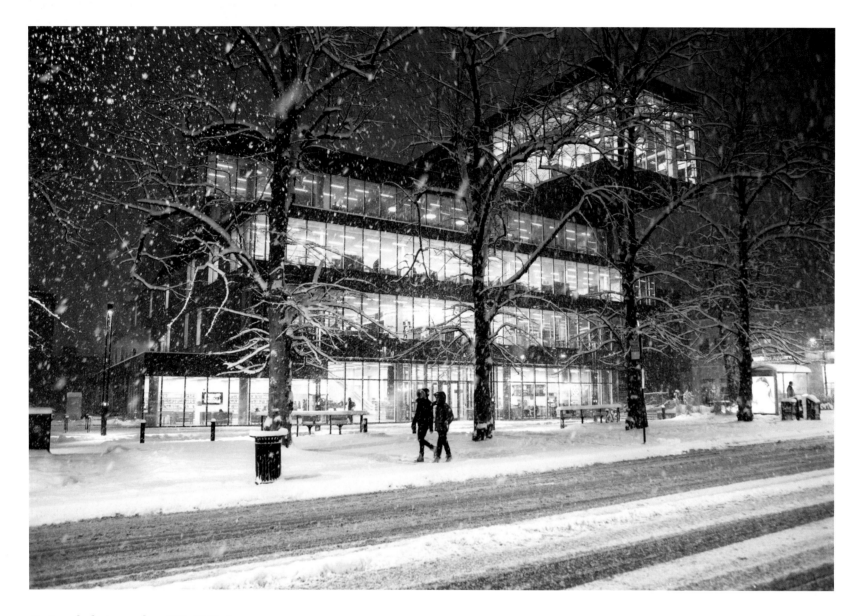

Featured photographer: T.J. McGuire

"Snow Globe" at Halifax Central Library in the winter of 2017. I happened to be on my usual walk home when large flakes of snow were falling, creating an incredible scene at our new library.

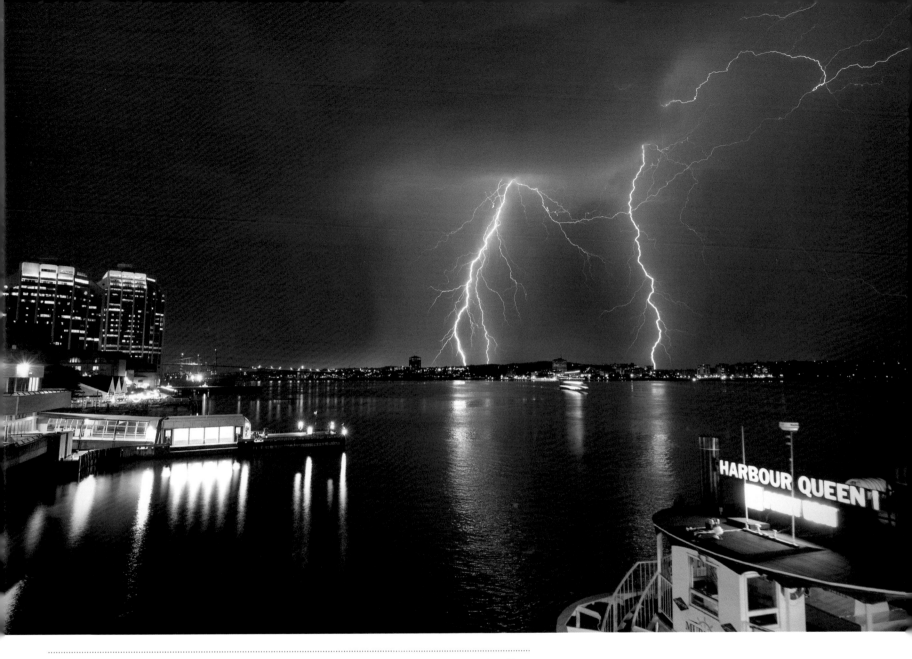

"Lightning Strike" over Halifax Harbour. Taken in the summer of 2016 during JazzFest on the waterfront. I was out taking photos of boats, but it began to rain so I started to pack up. Then I noticed a few strikes in the distance. Not having had a chance to shoot lightning before, I set my camera up and began shooting, hoping to catch something. I literally ran for shelter after this strike hit.

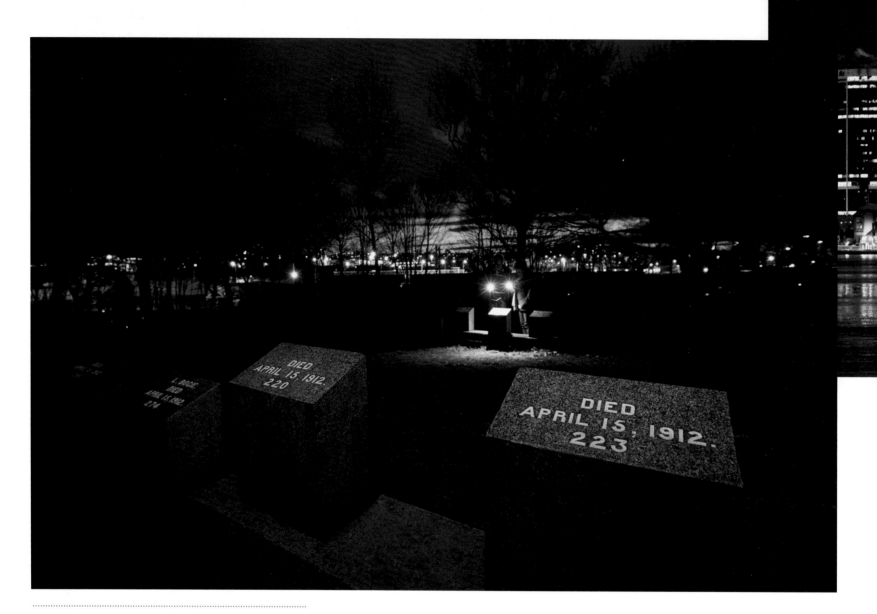

Visitors read the headstones of some of the vic-
tims of the *Titanic* disaster at the Fairview ceme-
tery in Halifax. The ship's maiden voyage became
one of the greatest marine disasters in history with
1,500 of the 2,200 on board lost. Halifax will for-
ever be tied to the tragedy, as 150 of the victims
are buried there.

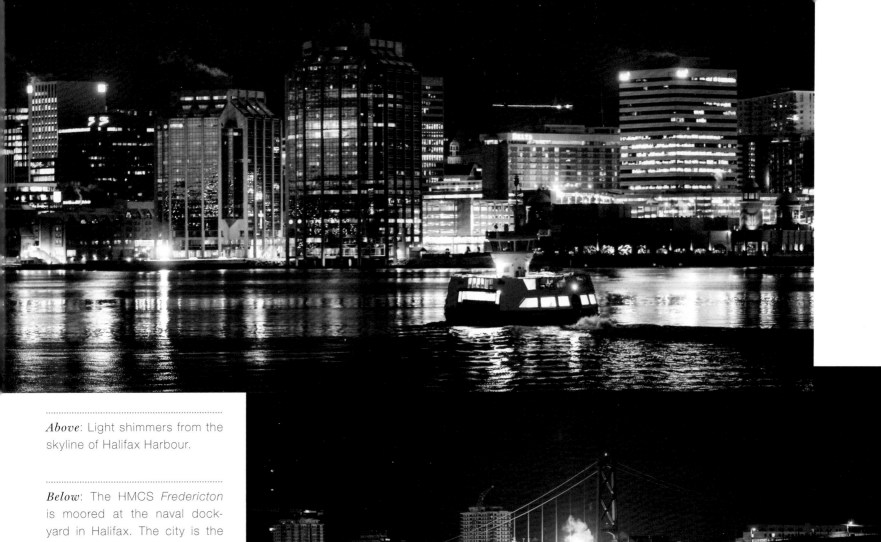

Above: Light shimmers from the skyline of Halifax Harbour.

Below: The HMCS *Fredericton* is moored at the naval dock-yard in Halifax. The city is the headquarters for Canada's east coast fleet.

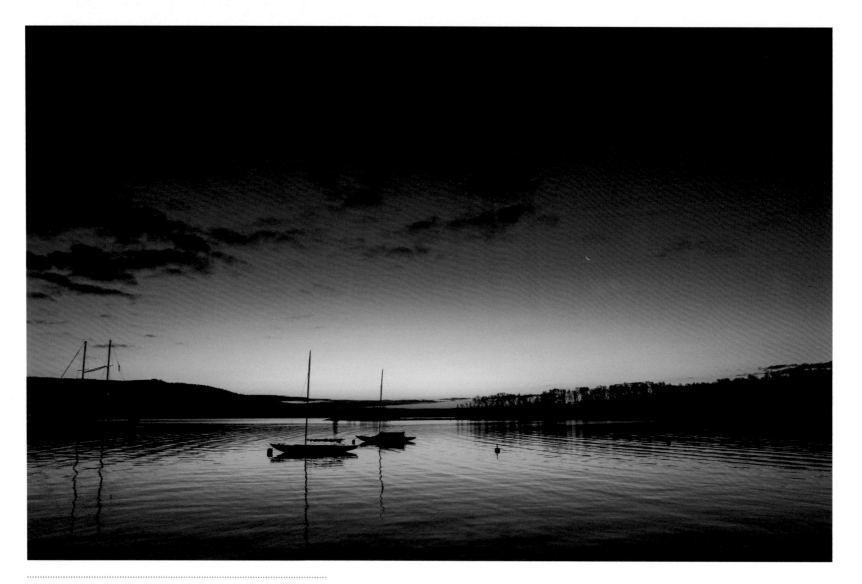

Dawn creeps over Baddeck Bay on Cape Breton Island. The village derives its name from the Mi'kmaq term *Abadak*, which has been translated as "place with an island near."

In the distance is the Beinn Bhreagh estate, where Alexander Graham Bell spent a great deal of his time and which is his final resting place.

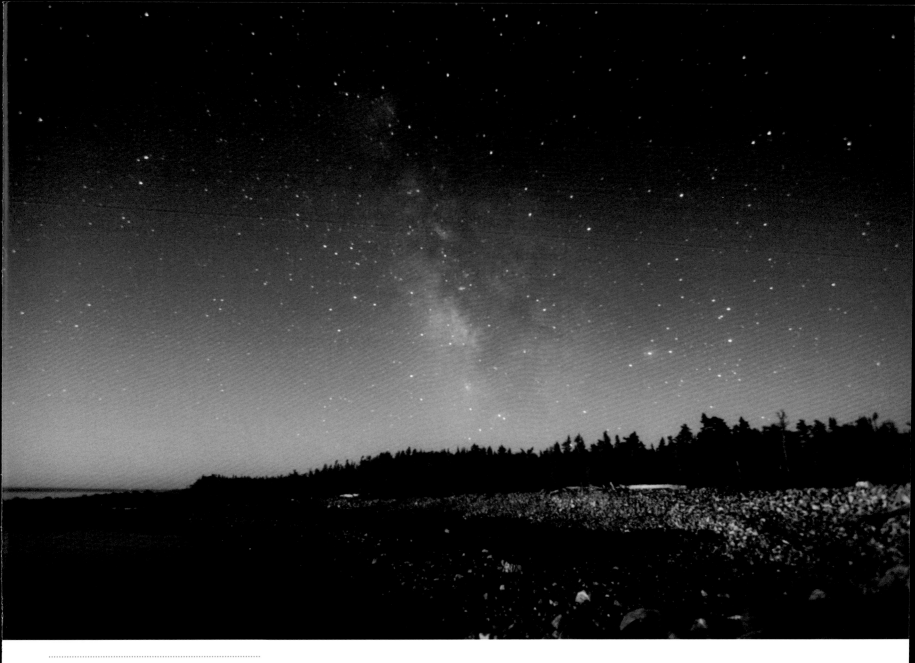

The Milky Way glows in night sky as it appears over Bon Portage Island off the province's southwestern coast.

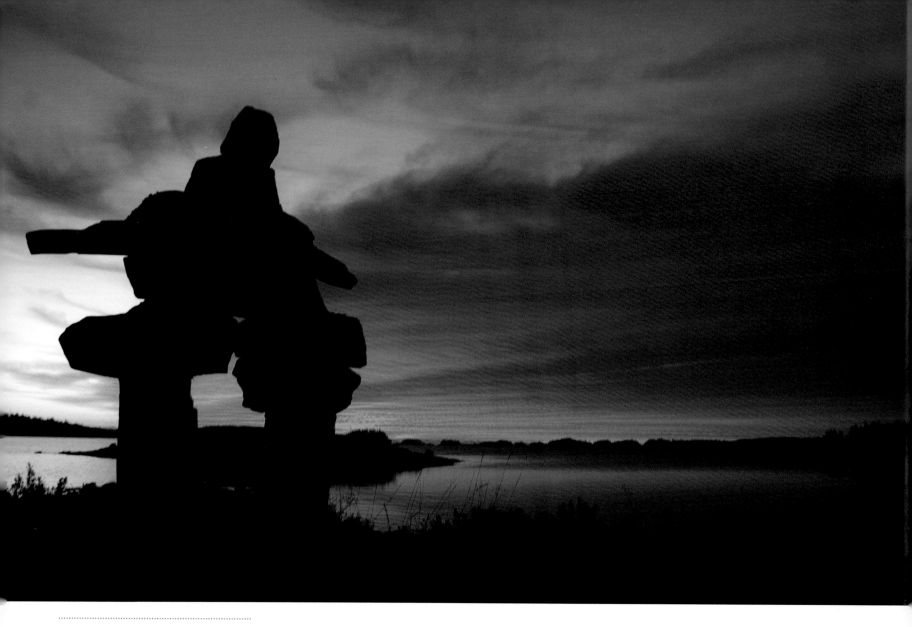

An inukshuk greets the morning sunrise on the eastern shore of the province. Inukshuks have their roots in the Inuit culture.

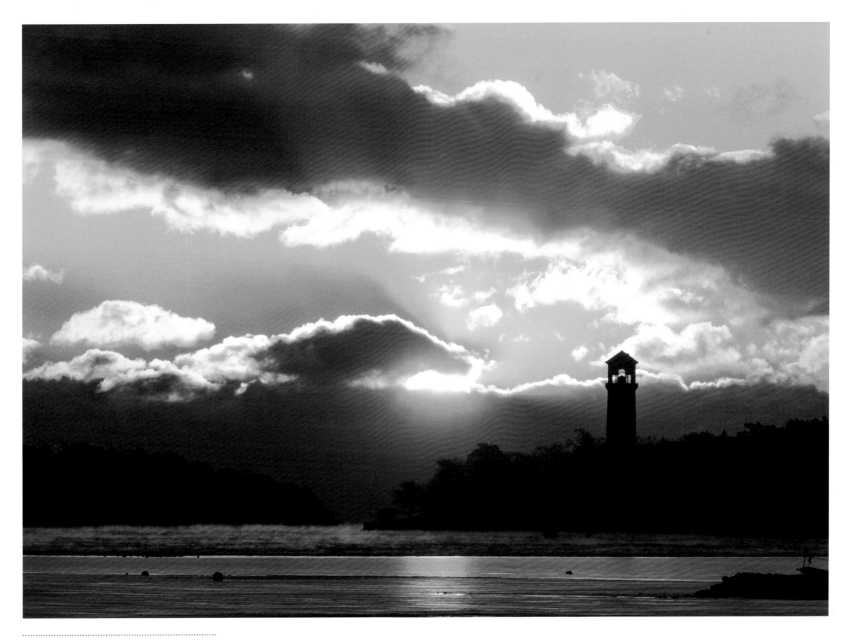

The sun illuminates the morning
sky over Northwest Arm in Halifax.

Night starts to give way to a new day
as the sun's rays colour the night sky
near Greenhill, Cumberland County.

ACKNOWLEDGEMENTS

I HAD A GREAT DEAL OF HELP PUTTING THIS BOOK TOGETHER AND AS ALWAYS AM IN DEBT to my family and friends who have helped me along the way.

Call display was invented for people like me, who call their friends on a cold February night and ask them to go for a hike in the dark.

This book started with a three-hour exposure of the night sky at a November camp at Kejimkujik National Park; that image is on the cover of the Nimbus Fall 2017 catalogue.

Thanks to Whitney Moran, senior editor, who listens to my ideas and pitches them for me. She has a wonderful way of keeping things on track and is always there to chat and help me with direction. All the good things about this project were probably her ideas! We are truly blessed in this region to have a company like Nimbus, run by Heather Bryan and Terrilee Bulger. Their work with authors and artists helps create and promote the culture of Atlantic Canada.

To all the people who follow me on Facebook, Instagram, Twitter, and lenwagg.com, it was fantastic to get your feedback on the images and your votes for the different frames and crops!

Thanks to Yailen Munoz Diaz and Brett Wagg who built my webpages and helped with social media.

For all the people who helped me with this project, thank you! Thanks to Darren Pittman for coming out on lots of shoots to enjoy the night sky. Thanks to Peter Hawkins and Cody Morris for lugging gear out to shoots. To Adam Young at Louisbourg, thanks for helping me with night images there.

Thanks to Jodi Wagg and Brett Byng for posing on a roof with the super moon rising in the back, and Kiya Willman and Sandy Wagg for taking walks in snowstorms. Thanks to Alan Blackwood for making sure the antique Mustang was at the right place at the right time.

I was happy to get a positive answer from Pam Collins of Wild Sweetpea Photography, T. J. McGuire, and Tim L. Esperance when I asked whether they'd like to be involved with this project. They all have fantastic eyes for photos and it is a treat to see what pops up in their social media feeds. If you'd like to follow them, their details can be found in their photo captions.

A special shout-out to Sandy Wagg for her support through this project. She helped lug gear, posed for pictures, and suggested angles for images. A big thank you for helping me talk my way out of yet another speeding ticket.